GORILLAS
in the Wild
A Visual Essay

Joe McDonald

AMHERST MEDIA, INC. ■ BUFFALO, NY

Conservation Efforts You Can Support

The Ellen DeGeneres Wildlife Fund
ellendegenereswildlifefund.org

The Dian Fossey Gorilla Fund International
https://gorillafund.org

Published by:
Amherst Media, Inc.
PO BOX 538
Buffalo, NY 14213
www.AmherstMedia.com

Publisher: Craig Alesse
Associate Publisher: Katie Kiss
Senior Editor/Production Manager: Michelle Perkins
Editors: Barbara A. Lynch-Johnt, Beth Alesse
Acquisitions Editor: Harvey Goldstein
Editorial Assistance from: Carey A. Miller, Roy Bakos, Jen Sexton-Riley, Rebecca Rudell
Business Manager: Sarah Loder
Marketing Associate: Tonya Flickinger

ISBN-13: 978-1-68203-396-8
Library of Congress Control Number: 2019932340
Printed in the United States of America
10 9 8 7 6 5 4 3 2 1

AUTHOR A BOOK WITH AMHERST MEDIA

Are you an accomplished photographer with devoted fans? Consider authoring a book with us and share your quality images and wisdom with your fans. It's a great way to build your business and brand through a high-quality, full-color printed book sold worldwide. Our experienced team makes it easy and rewarding for each book sold—no cost to you. E-mail **submissions@amherstmedia.com** *today.*

www.facebook.com/AmherstMediaInc
www.youtube.com/AmherstMedia
www.twitter.com/AmherstMedia
www.instagram.com/amherstmediaphotobooks

CONTENTS

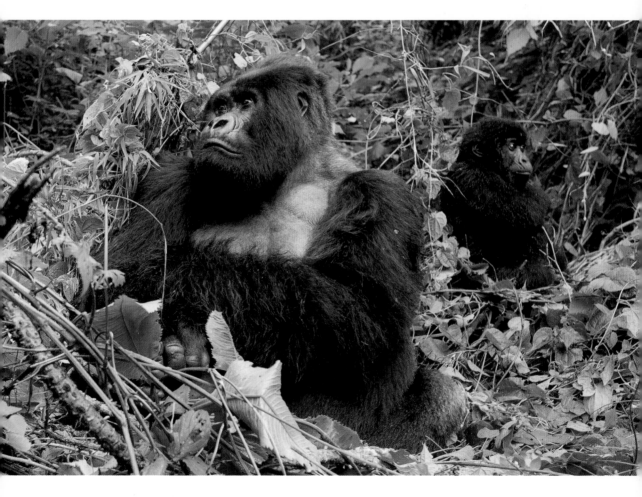

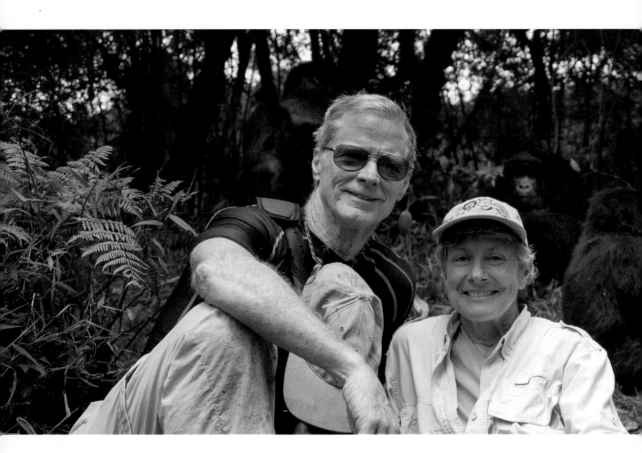

About Joe and Mary Ann McDonald

Joe and Mary Ann McDonald hold the unofficial "world record" for the most mountain gorilla treks for any tourist in Rwanda. They have completed over 100 treks each, amassing a photographic collection of mountain gorillas unsurpassed by any other photography team. Joe's mountain gorilla photographs have won awards in the prestigious BBC Wildlife Photographer of the Year competition three times, and both Mary Ann and Joe have had the honor of naming a baby gorilla in Rwanda's annual Kwitza Inza ceremony, perhaps the highest honor one can have in the world of gorilla conservation. Their photo tours to Rwanda have contributed over a million dollars to the local economy.

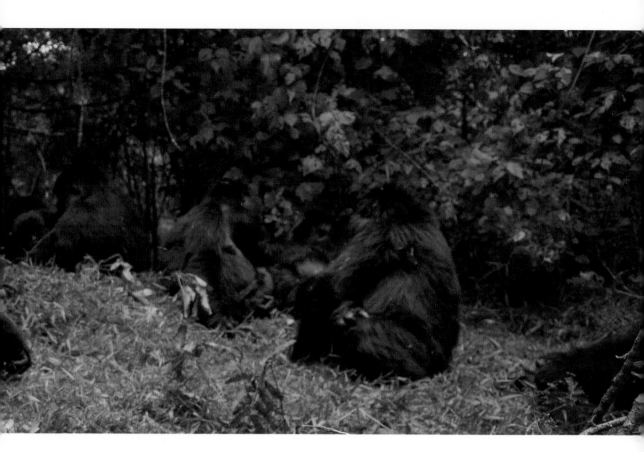

Acknowledgments

One hundred and one treks would not have been possible without the help of a lot of folks. First and foremost, we must thank the scores of people who have trekked with us, sharing our adventures in Rwanda. Joseph Birori of Primate Safaris, and our in-country guide Alex Kagaba, have been of invaluable assistance, and every person at Primate Safaris has become a great friend. So, too, we must thank Paul Muvunyi, the owner of Mountain Gorilla View Lodge, our base when we're in the Virungas, and Steve Turner, the owner of Origins Safaris, our ground operator in Kenya. The RPG staff, including Anaclet Budahra, tourism warden, and Prosper Uwingeli, chief park warden, have been incredibly helpful with our groups, as have all the gorilla trackers and guides we've had over the years.

Special thanks also goes to Joe Johnson and the staff of Really Right Stuff for their support, literally, with the fine monopods and monopod heads we use; to Lou Schmidt of Hoodman cards and video gear; to my friend, Steve Metildi, for his chimpanzee and orangutan photos, and to Ken Hubbard of Tamron for their wonderful telephoto lenses.

Last, all of these treks would not have been as much fun, or photographically rewarding, if I had not shared these experiences with my wife, Mary Ann. Together, we've done all 101 treks— 202 between us—thus doubling our coverage with different lenses and angles, while loving every minute of it!

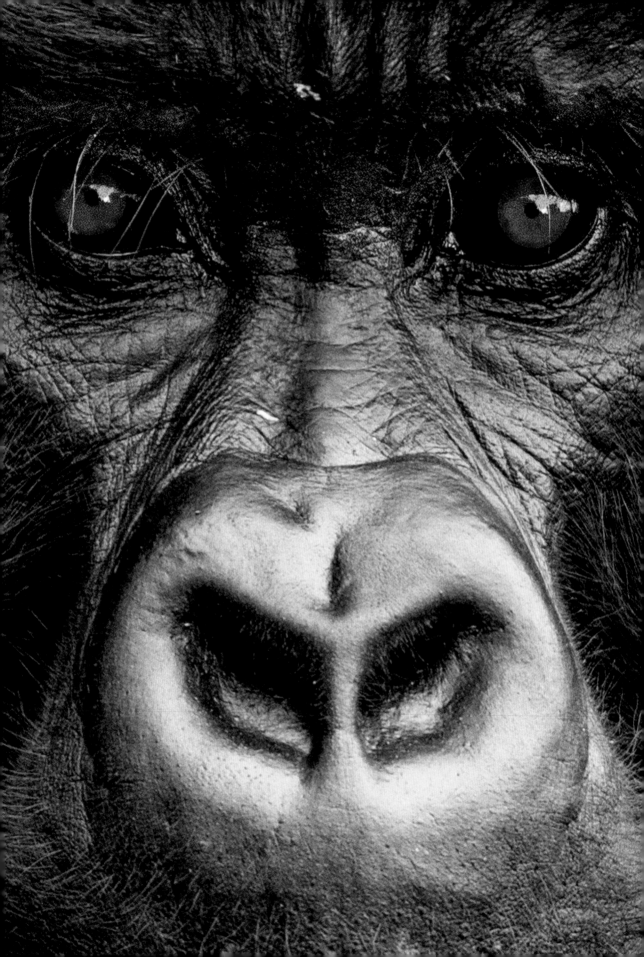

MEET THE GORILLA

I have to confess, the first time I encountered a mountain gorilla in Rwanda, I had to laugh. Not that I found the animal or the situation funny, but I had to chuckle quietly out of the sheer joy and wonderment I felt. Some folks shed a tear or openly weep during their first encounter; the experience can be that moving. Since that first trek to Rwanda's mountain gorillas, my wife Mary Ann and I have completed 100 more treks, and we find every one of them as touching and as exciting as our first.

Some folks shed a tear or openly weep during their first encounter; the experience can be that moving.

Contrast those true emotions and experiences with the popular culture's treatment of the gorilla. As a kid, my first exposure to gorillas was the original *King Kong* movie, in which a giant, ferocious gorilla turned out to have a real soft side. Adventure documentaries aired in the early 1960s also cultivated the image of a dangerous, aggressive beast that charged, screaming and crashing, toward a brave film maker.

The gorilla's image began to change with the groundbreaking work of zoologist George Schaller, who was the first to attempt a field study of mountain gorillas. His efforts resulted in one of the first, if not the first, book on gorillas in the wild, entitled *The Year of the Gorilla.* Most folks probably haven't heard of Schaller, perhaps the greatest field zoologist ever, but virtually every nature lover knows the name Dian Fossey. Recruited by the anthropologist Louis Leakey to do field research on mountain gorillas, Fossey took the study of mountain gorillas to a whole new level as she habituated the gorillas to her presence. She became a media celebrity, appearing in nature documentaries and in articles in *National Geographic,* and from the publication of her general audience book, *Gorillas in the Mist.* That book later was adapted into a movie starring Sigourney Weaver, which further advanced the public's exposure to this gentle giant.

Today, the public perception of the mountain gorilla reflects their true nature, a fascinating, gentle, yet fiercely protective member of the same family of primates, Hominidae, that we too belong. This family also includes chimpanzees and bonobos, three species of orangutan, and the two gorilla species. There has been a lot of confusion regarding gorilla classification, with the popular misconception being there was a mountain gorilla, inhabiting the volcanoes of east-central Africa, and a lowland gorilla, inhabiting the lowland jungles in east-central and west Africa. That notion is false.

Mountain Gorilla *(previous page).* The intense gaze of a silverback, an adult male mountain gorilla, can be intimidating and frightening, belying the true nature of this gentle beast.

Technically, the mountain gorilla (Gorilla beringei beringei) is one of two subspecies now classified as the eastern gorilla. The other subspecies is the eastern lowland gorilla (Gorilla beringei graueri), inhabiting lower elevations, in the thick jungles of eastern DRC (Democratic Republic of the Congo). The other species, the western gorilla (Gorilla gorilla), is found on the far west side of Africa, inhabiting the countries of Guinea, Cameroon, CAR (Central African Republic), and the far western forests of the DRC. This species also has a subspecies, the Cross River gorilla (Gorilla gorilla diehli), that has the distinction of being the rarest of them all, with fewer than 300 surviving.

It is the mountain gorilla, however, that has seized the public's attention, and deservedly so. In contrast to the western species, whose population may exceed 90,000 animals, the

It is the mountain gorilla, however, that has seized the public's attention . . .

Mountain Gorilla and Joe *(below)*. Visitors are required to keep seven meters from a gorilla or a family, which minimizes the chances of transmitting any human-borne illness and lessens the temptation for any interaction on the gorilla's part. Gorillas don't read, and frequently approach closer than the minimum distance, requiring tourists to back up.

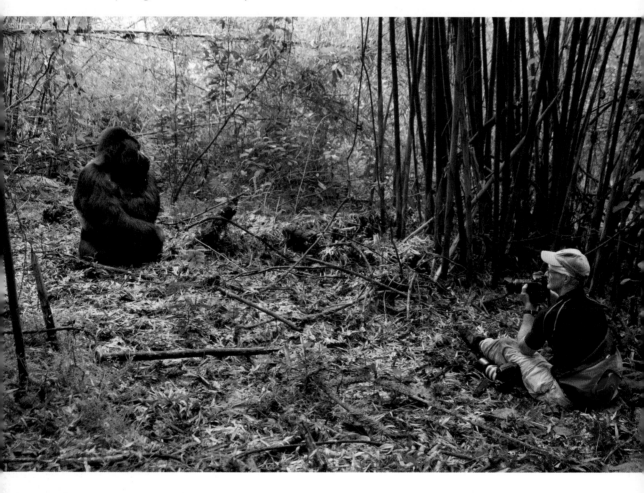

Mountain Gorilla Silverback.
The mountain king holds court in a clearing in a bamboo forest. That's the impression one has when encountering a regal silverback sitting relaxed and unconcerned , seemingly oblivious to human presence.

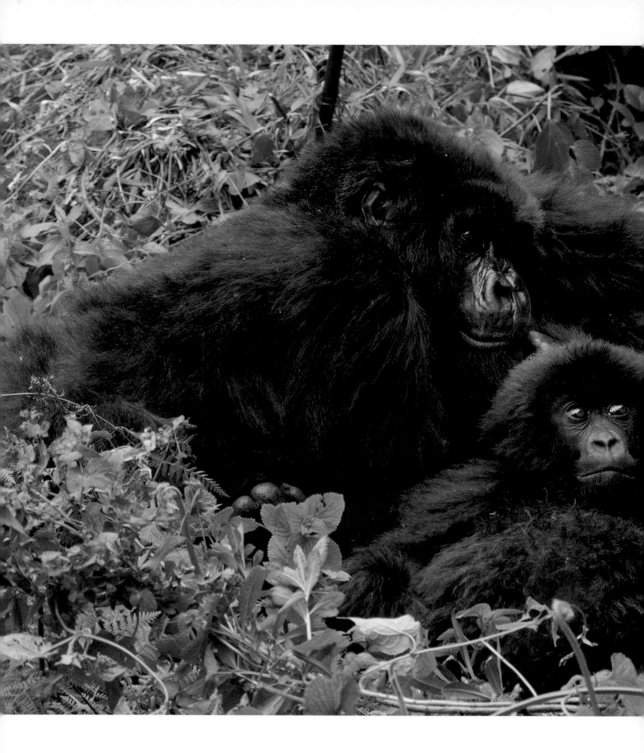

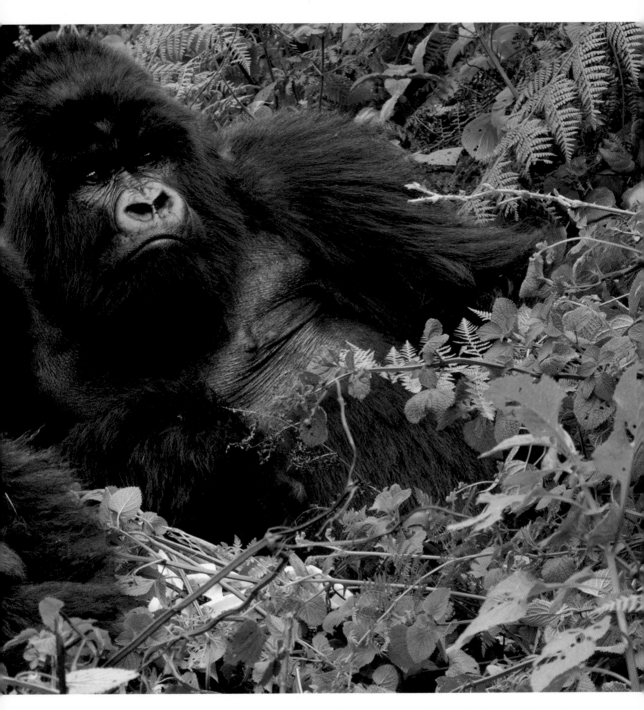

Mountain Gorilla Family *(above)*. Mountain gorillas live in family groups, led by a dominant adult male silverback, that may consist of only a few females and babies, while another group may have 30 or more adults. Gorillas are quite social, and both sexes may snuggle together, with their young huddled close.

eastern gorilla's total population numbers less than 5,000 animals, including the mountain gorillas, whose population is very vulnerable, as I'll explain later.

The current mountain gorilla population is thought to number around 1,000 individuals, dispersed across the Virunga Mountains, a series of presently dormant volcanoes that straddle Uganda, Rwanda, and the DRC, with Rwanda having a majority of this population, with 604 individuals in the latest census. Uganda has another population, presently considered a true mountain gorilla, isolated in the intimidatingly named Bwindi Impenetrable Forest. This group may, someday, be considered still another subspecies of the eastern gorilla. As you can see, classification of gorillas is a bit confusing.

I've visited the gorillas in Bwindi, and my untrained eyes led me to think that the true mountain gorillas, the subject of this book, are those that dwell on the volcanic slopes of the Virungas. So, enough with this history and classification background; let me share with you one of the all-time greatest nature/wildlife experiences one could ever have!

The current mountain gorilla population is thought to number around 1,000 individuals . . .

Female Mountain Gorilla *(following page)*. It was pouring rain when we began the trek to this family group, and several of my friends considered cancelling. Luckily, we pressed on, and I was able to capture this shot, a prestigious BBC Wildlife Photographer of the Year winner. I could have missed it.

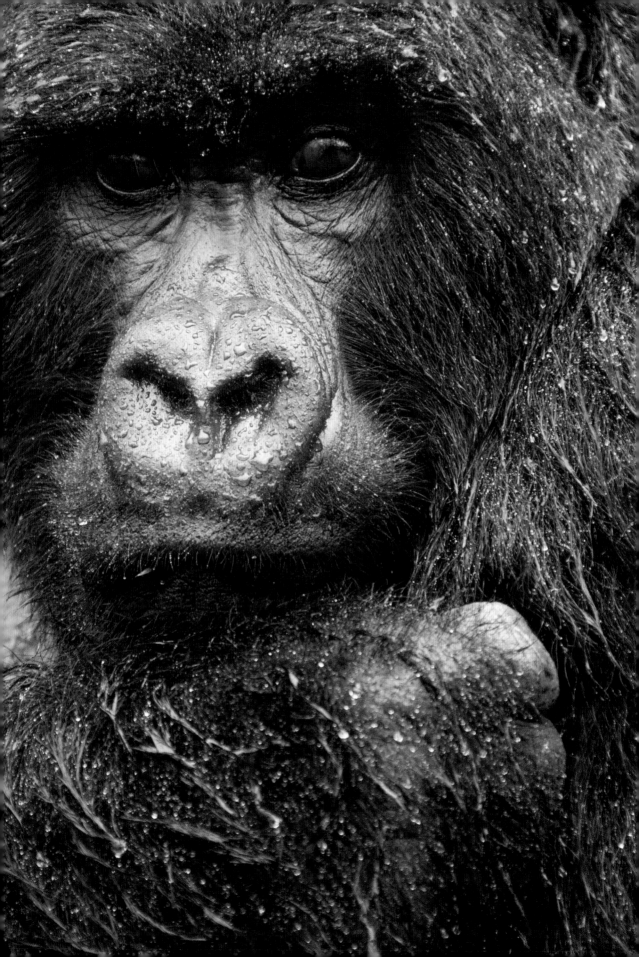

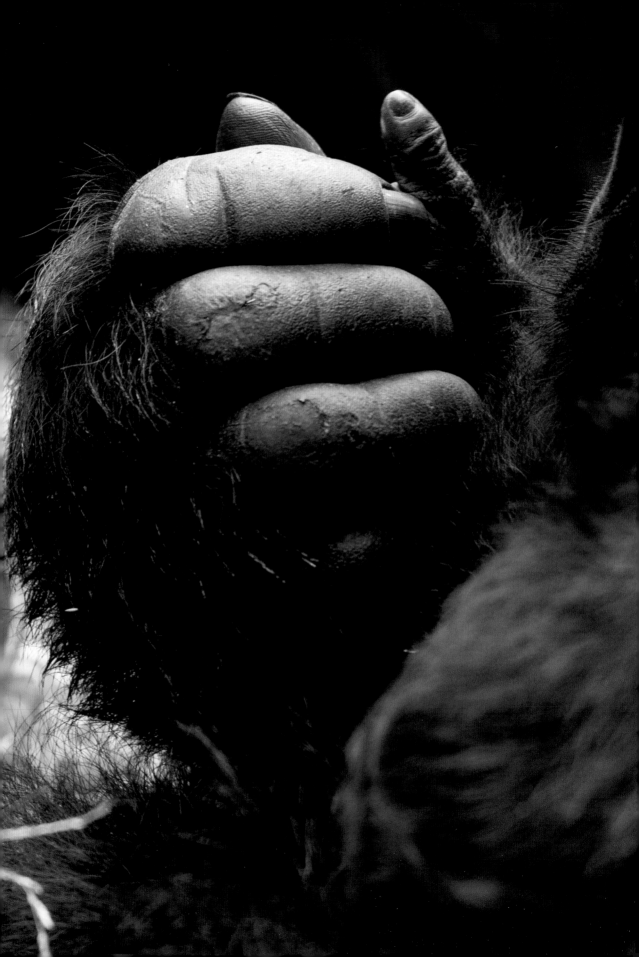

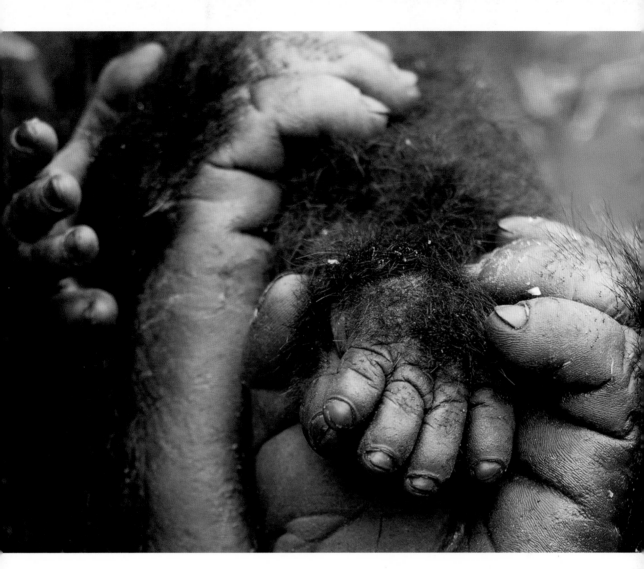

Gorilla Mother's Hand and Baby's Hand *(previous page)* and **Gorilla Mother's Foot and Baby's Hand** *(above)*. There are many reasons why we're so fascinated by and enamored with gorillas, and one of these must be the tenderness and care exhibited by a mother with her baby.

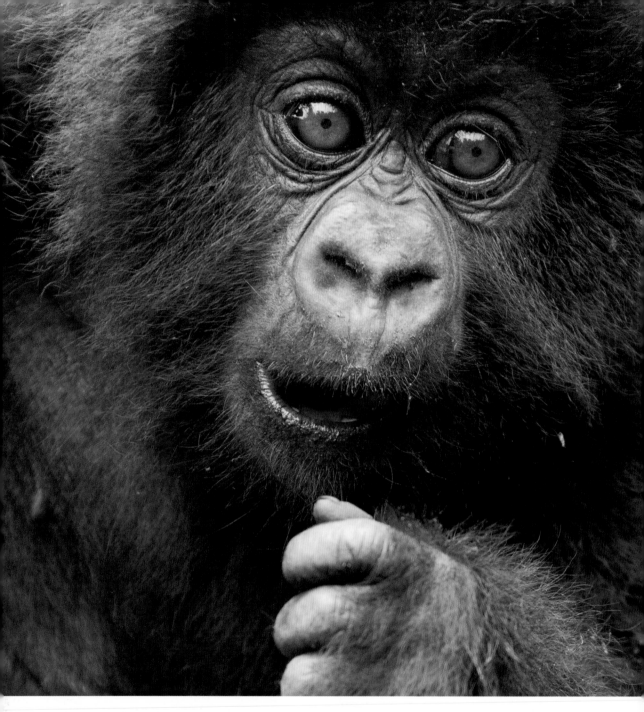

Baby Gorilla *(above)*. A wide-eyed look clearly reveals the curious nature of a young gorilla. Although babies less than two years old rarely stray from their mothers' arms, older youngsters are curious and adventurous. Frequently, our forest guides must utter an "uuhh, uuhh, uuhh" grunt—gorilla talk for "no, no, no."

Baby Gorilla *(following page, top)*. Holding a hand to his mouth as if embarrassed, there's little difference between this baby gorilla's expression and that of a human child.

Contemplation *(following page, bottom)*. Scratching his chin as if in thought, this gorilla appears to contemplate some weighty problem. These poses and postures are so human-like, and such a clear reflection of our common ancestry.

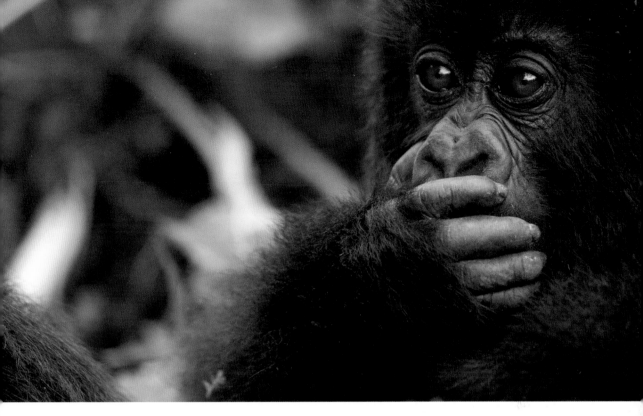
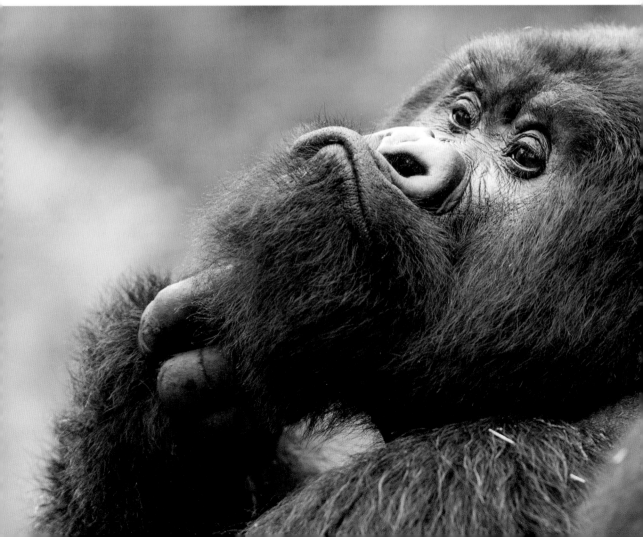

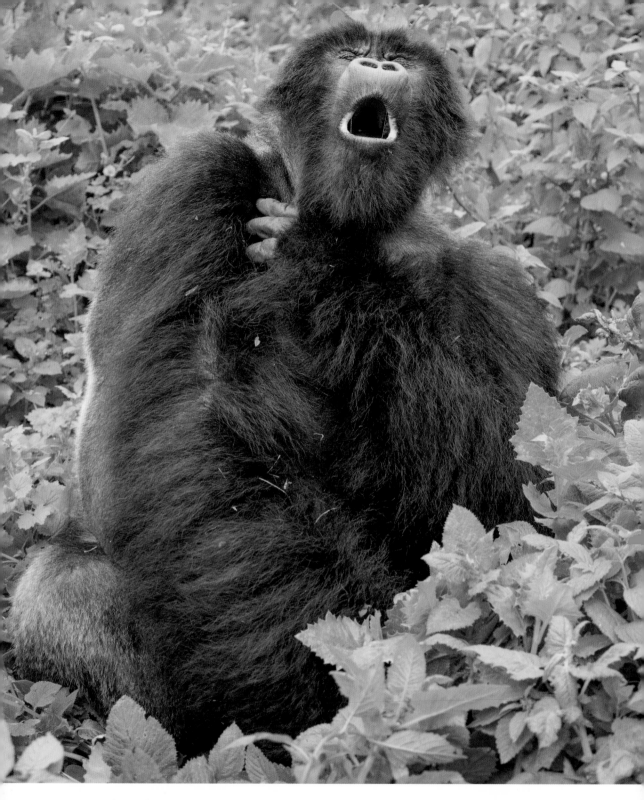

The Singer *(above)* and **The Critic** *(following page)*. Caught at the conclusion of a tooth-baring yawn, this gorilla appears to be singing or howling at the moon. Another gorilla, caught with a grimace, might be critiquing that performance.

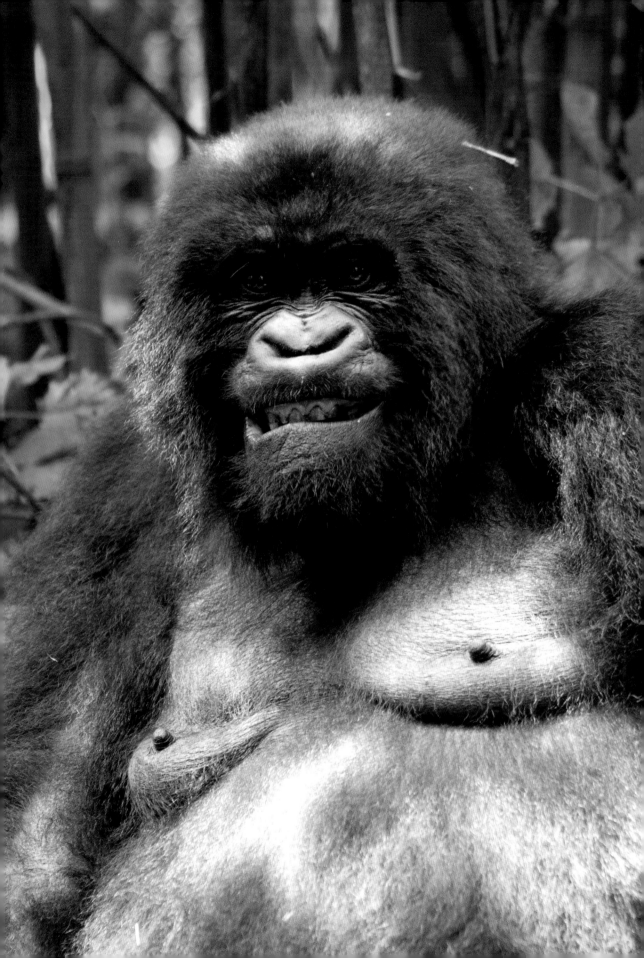

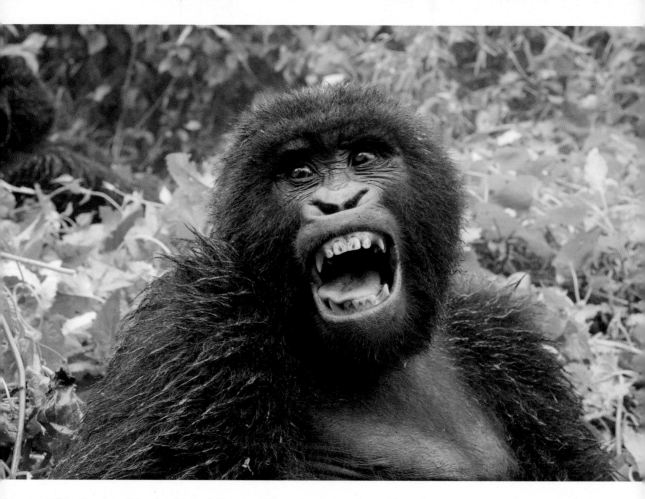

Wide-Eyed and Toothy *(above).* The dentition of a mountain gorilla reflects our similar ancestry. In gorillas and most primates, the canine teeth, called cuspids in humans, are enlarged as fangs. With gorillas, the fangs can function in defense, but will also be used to shave off the bark they strip from trees.

Grimacing Juvenile *(following page).* This young mountain gorilla looks as if he was just caught doing something naughty. The similarity of expressions that we share is one of the endearing qualities that draw us to these animals.

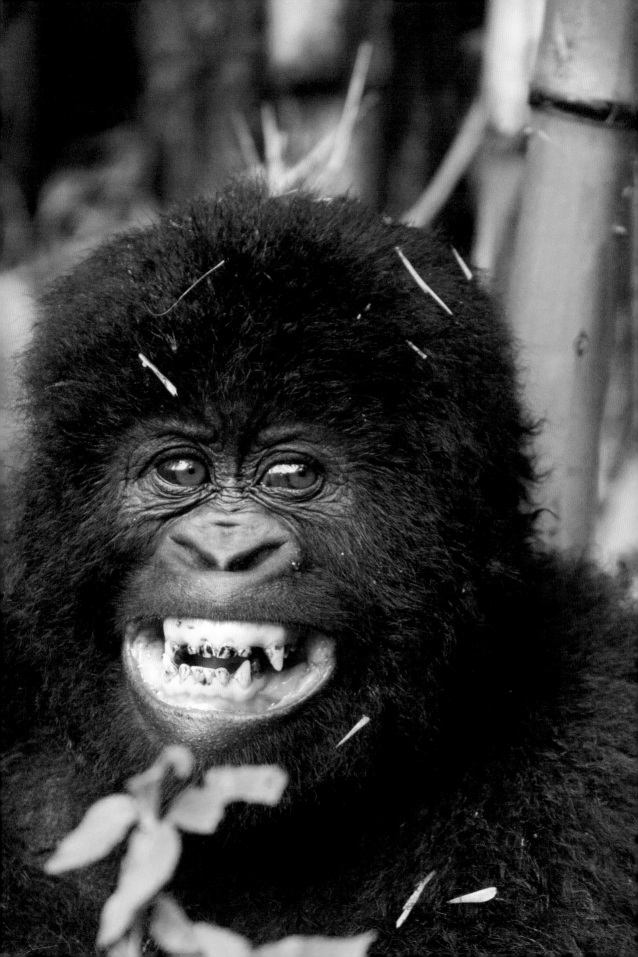

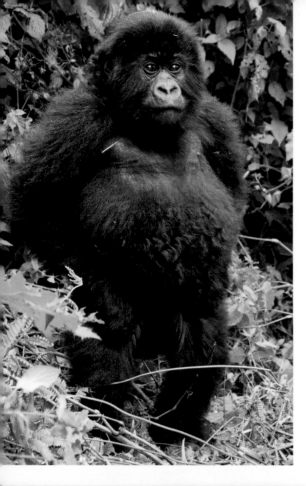

Young Gorilla Standing *(left)*. I could think of several funny captions for this pose, but I'll leave this one to you. Gorillas can stand upright, and males, when chest-beating, may run on two legs for several yards, but most of their time, they are on all fours.

Silverback *(following page, top)*. If you look closely, you'll note that this silverback isn't staring directly into the lens. Gorillas, like most wild animals, rarely give direct eye contact. Doing so is an aggressive act, and one you would want to avoid.

Silverback in Clearing *(below)*. Mountain gorillas share the forest with other large animals, like the African buffalo, and forest elephants (a smaller variety of the huge African elephant). There are no lions in the jungle, and though leopards may be present, there are no records of attacks from this much smaller cat.

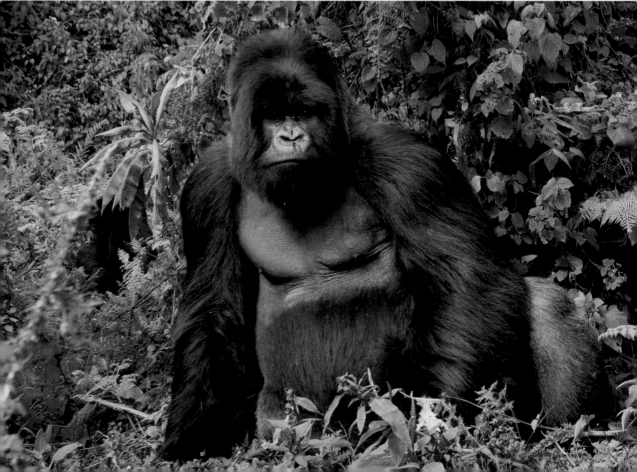

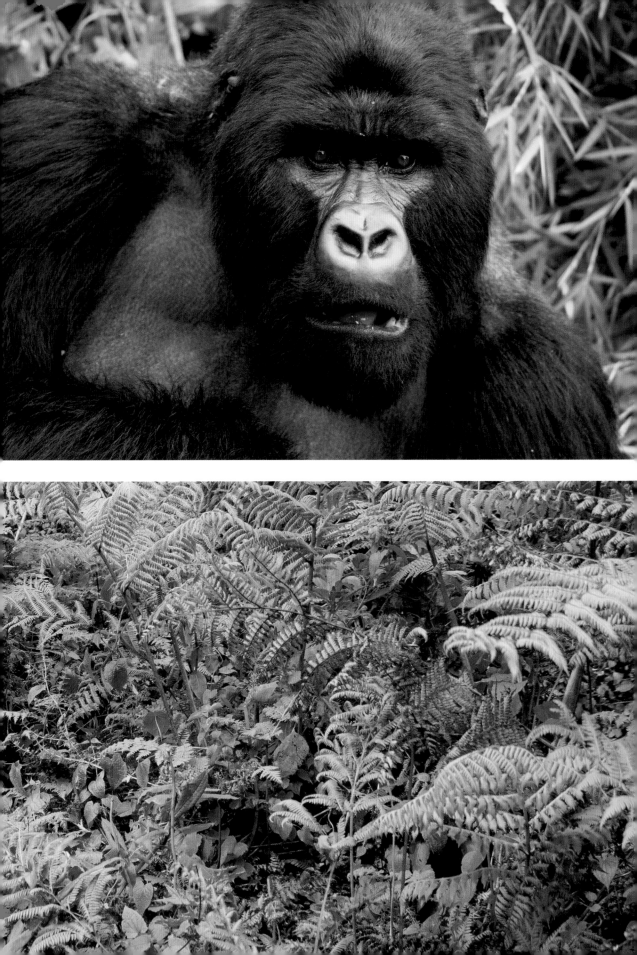

Silverback in a High Tree. One might naturally assume that the forest-dwelling mountain gorillas were great tree climbers, and indeed young gorillas and females often climb. Males, who might weigh over 450 pounds, do so less frequently, as the strength of many branches would not support their much heavier bodies.

Silverback on Trail. Adult males are known as silverbacks and spend most of their time on the ground. While females and young will make crude nests constructed of bent branches for sleeping, males usually sleep on the ground.

Silverback *(above).* Mountain gorillas are incredibly strong and are quite capable of going through some-thing, like thick brush and shrubs, rather than around them. Watching a gorilla crash through seemingly impenetrable vegetation is indeed humbling.

Silverback *(following page).* Park regulations require tourists to stay seven meters, about 22 feet, away from the gorillas. Sometimes that is impossible, as when a gorilla suddenly emerges from the vegetation and saunters down a trail. This enormous male could have patted me on the head; he was that close as he passed.

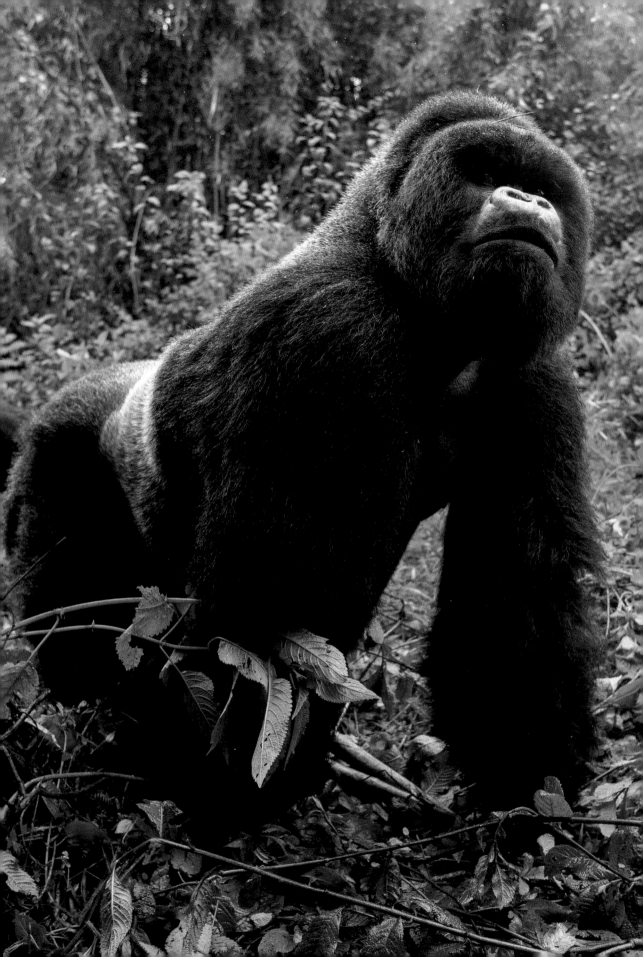

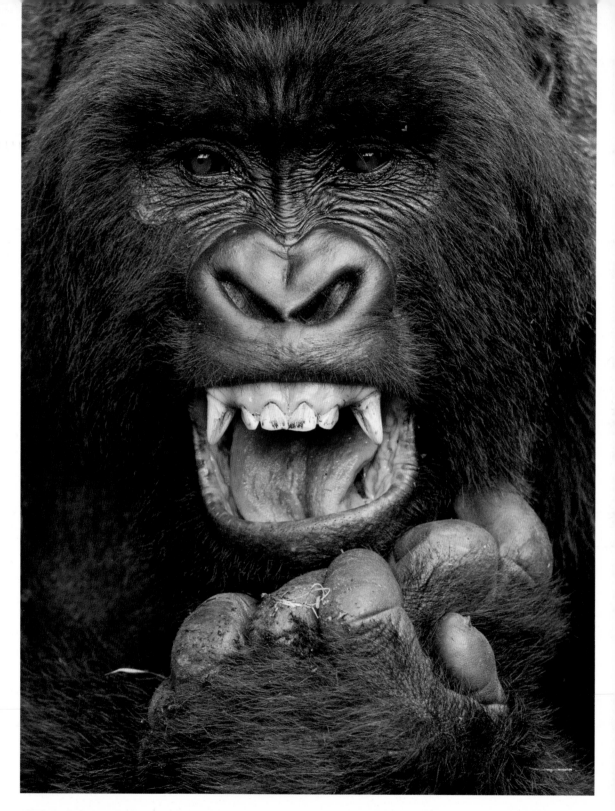

Silverback Grimace *(above).* While this pose may look frightening, Mary caught this mountain gorilla at the conclusion of a long yawn. Although gorillas do not eat meat or kill prey, excepting ants and termites, their fangs are formidable and can inflict terrible wounds.

Silverback Beating His Chest. Perhaps the stereotypical perception of a silverback is a chest-beating monster charging down a trail. Though this behavior might be practiced almost daily, for a photographer to catch it, one must be in the right place at the right time. More often than not, the gorilla is facing the wrong way.

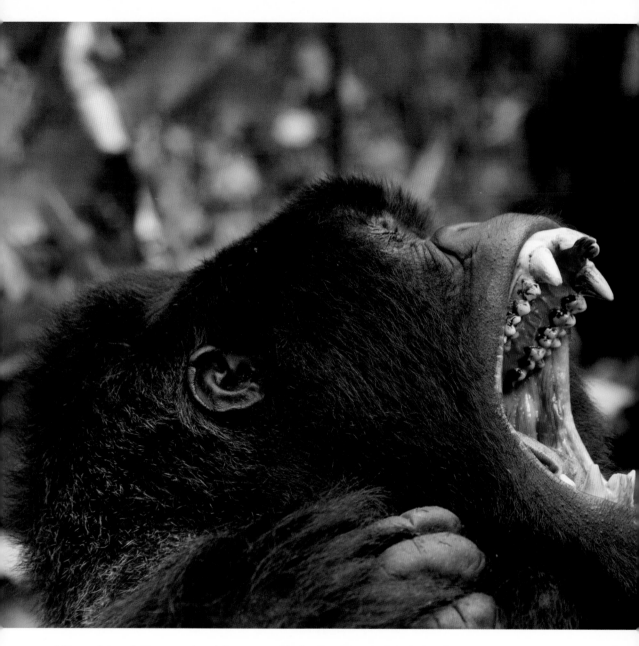

A Yawn *(above)*. Most tourist visits to a gorilla family occur during their "siesta time," a mid-morning break from feeding when gorillas rest or sleep. Yawns are not uncommon during this time.

Silverback Yawn *(following page, top)*. The long fangs, or canines, of this fully mature silverback are visible in this wide yawn. Gorillas are quite capable of literally biting your head off, but there is little to fear or worry about with these gentle giants.

Heading Down the Trail *(following page, bottom)*. Silverbacks control their group. Although a family may disperse widely in a forest and be out of view of one another, they nevertheless stay in contact. When the boss, the silverback, decides to leave, the rest soon follow.

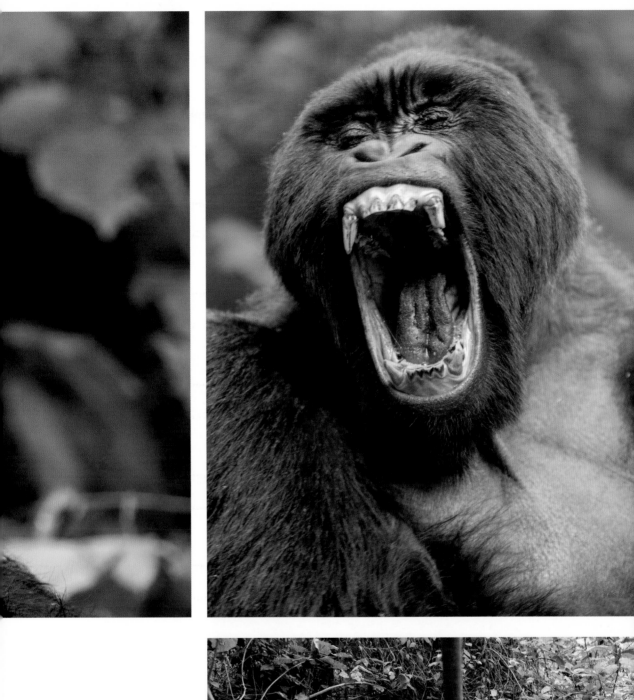

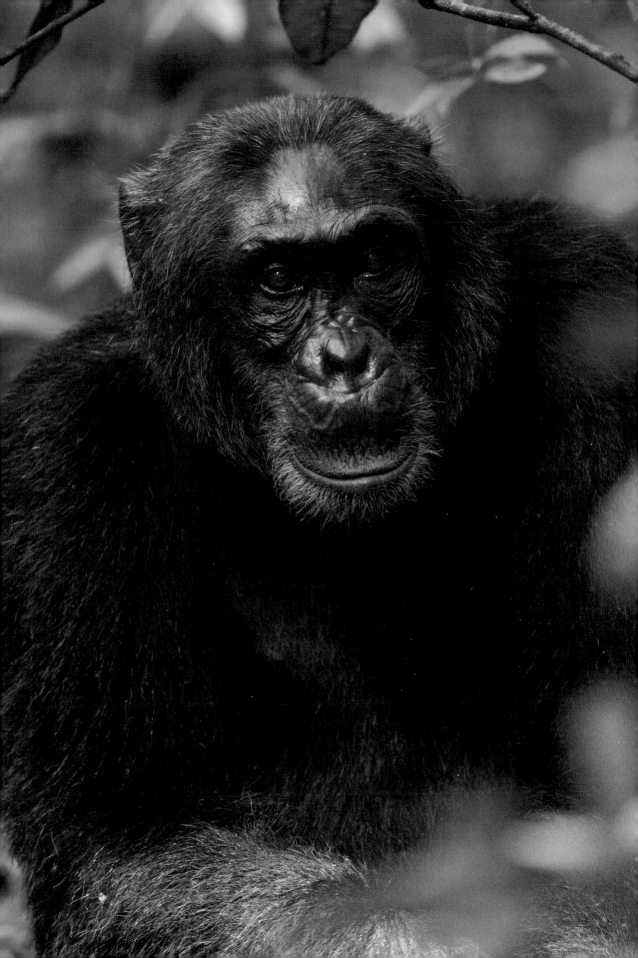

THE OTHER GREAT APES

In addition to the two species of gorilla, the eastern and western, there are six other species of great apes. One, you know very well; to see that species, just look in the mirror! Most people are very familiar with chimpanzees, found in the jungles of Central and West Africa, which are often exhibited at zoos and, in the past, were exploited for TV commercials and programs. A closely related species, the bonobo, was once thought to be only a subspecies of the chimpanzee. Bonobos have a very limited range in the forests of the DRC. The third type, the "wild man of the woods," is the arboreal orangutan, found only on the islands of Borneo and Sumatra. As of November 2017, there are three distinct species of orangutan recognized.

Most people are very familiar with chimpanzees, found in the jungles of Central and West Africa . . .

Chimpanzee *(previous page).* Photo by Steve Metildi. Chimpanzees live in large social communities, consisting of as many as 50 members, often with several adult males in each group. Unlike gorillas, chimpanzees can be quite aggressive with their neighbors, and will eat meat when they have the chance.

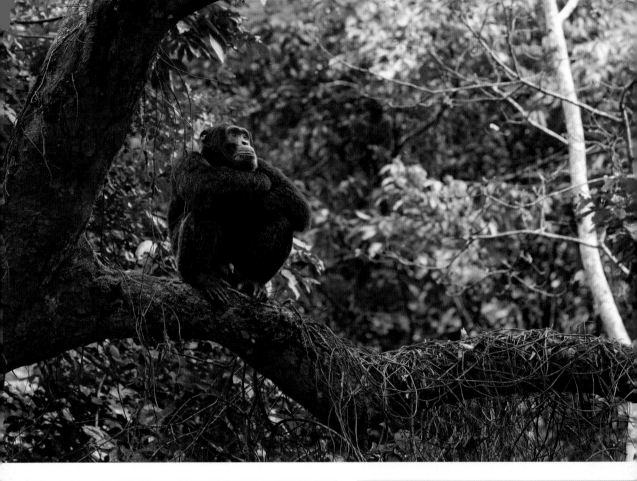

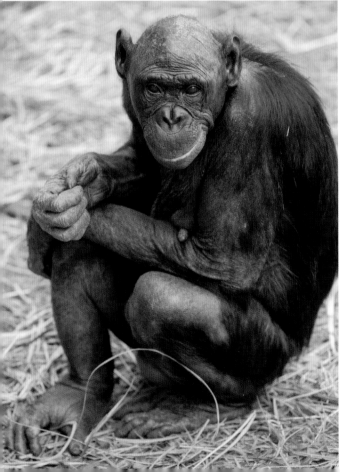

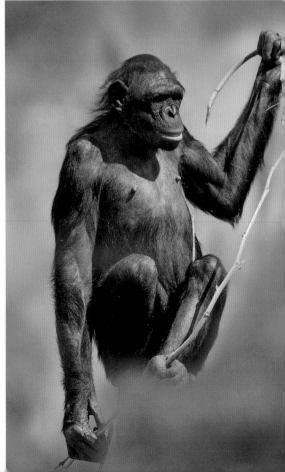

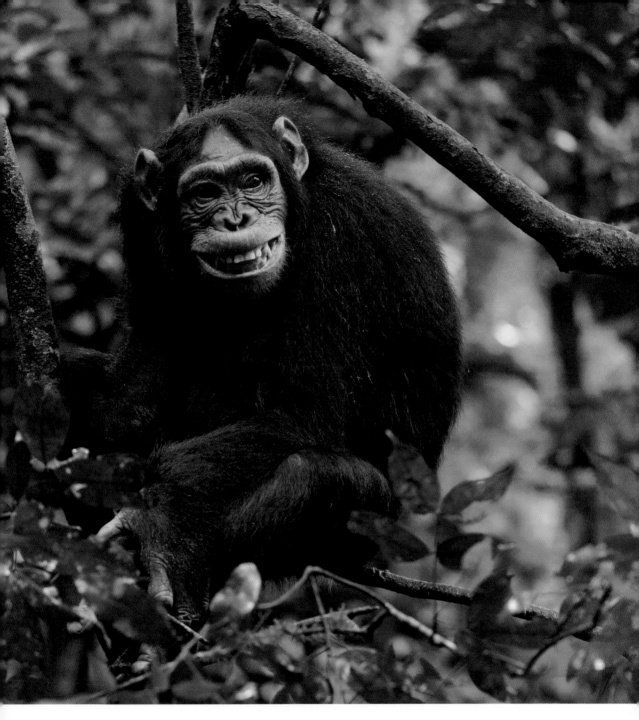

Chimpanzee in a Tree *(previous page top and above).* Photos by Steve Metildi. Chimpanzees forage both on the ground and in trees, and they are excellent, agile climbers, able to chase down and ambush the monkeys they will hunt for food.

Bonobo *(previous page, bottom left and right).* It is easy to see the close genetic relationship between humans and bonobos, as they and chimpanzees are our closest relatives. Sadly, no one knows how many bonobos still live in the wild, with estimates ranging from as low as 5,000 to as many as 20,000. These bonobos were part of a zoo exhibit.

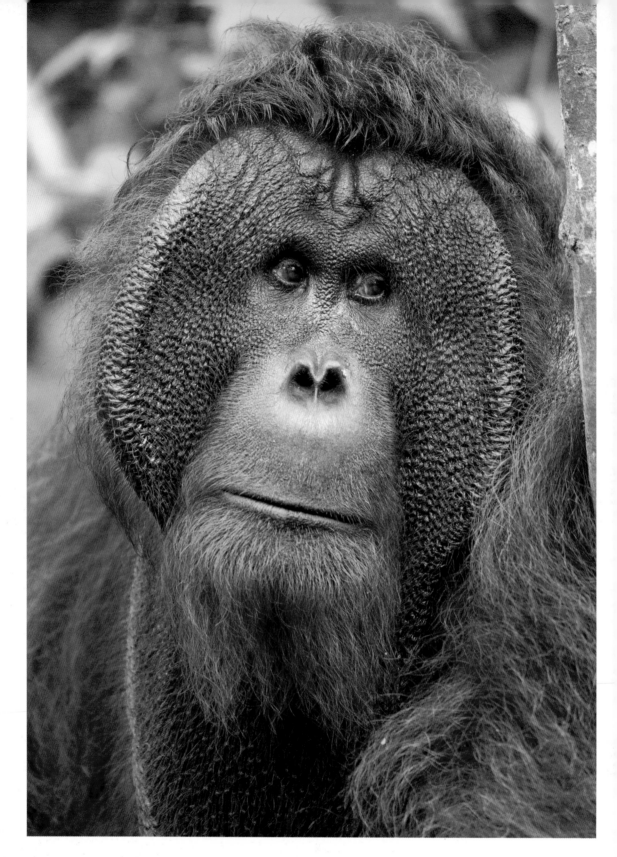

Orangutan Male *(this page)* and **Orangutan Female** *(following page)*. Photos by Steve Metildi. Male orangutans typically have a broad, dish-like face, while the female's expressive face is slender. Unlike gorillas, chimpanzees, and bonobos, the fur of orangutans is a colorful orange.

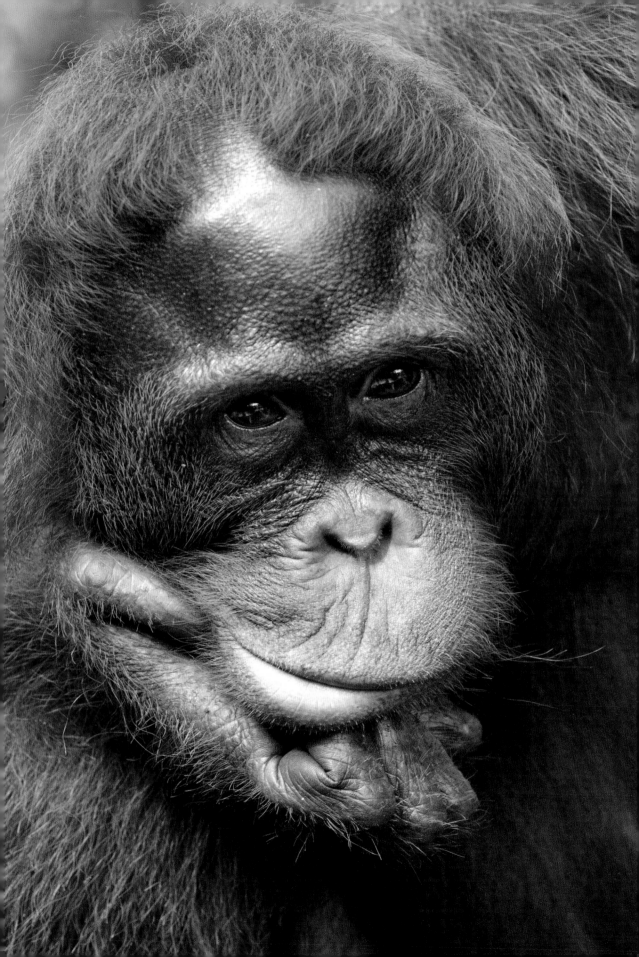

Orangutan Mother and Baby.
Photo by Steve Metildi.
Orangutans are great tree
climbers and have a great
arm span, allowing them to
easily move through trees.

Male Orangutan. Photo by Steve Metildi. It's easy to see why the orangutan's name means "wild man of the woods." Other translations of the word trade "wild" for "wise," which would be equally appropriate, as many consider orangutans to be the most intelligent of the wild great apes.

Land of a Thousand Hills. Mists, due to ground fog and wood smoke from heating or cooking, cloak the valleys at dawn.

THE VIRUNGAS

As I wrote this book, Hawaii's Kilauea volcano was still spewing lava into the sea, destroying over 700 homes in the process. Dormant volcanoes, those presently not active, can wake up at any moment and create destruction. It is in the shadow of five presently "sleeping" volcanoes that the world's mountain gorillas live.

All of the gorilla images in this book were made during our 101 treks to the mountain gorillas of Rwanda, a country sometimes called "the Land of a Thousand Hills" or "the Switzerland of Africa." Both names are apt, as this country ripples with an endless series of hills and mountains, creating a beautiful panorama reminiscent of Switzerland. One of the smallest countries in Africa, Rwanda is only $1/26$ the size of Texas. Rwanda has the dubious distinction of being one of the most densely populated countries in the world, presently with over 12 million people, with an average population density of over 1,300 people per square mile. That population is projected to nearly double by 2050.

These two sobering facts highlight the mountain gorilla's tenuous existence. As the human population expands adjacent to the gorillas' range, increasing pressure may be placed on their forests, the only land still available for food, fuel, or living space. While the threat from a volcano is quite low, especially when compared to the problems associated with population growth, that minuscule threat still exists. We've seen the ash plumes and smoke of volcanoes erupting in the DRC from park headquarters in Rwanda, highlighting the fact that the landscape can change at any time.

The uniqueness of the mountain gorillas was recognized early, and the present park saw its first protection in 1925, while the area was still under Belgian rule. Subsequently, Rwanda and the DRC gained independence, and Rwanda took control of its section of the park. In the years following, the park's size was reduced by more than half, resulting in its present size of approximately 130 square kilometers, about 50 square miles.

Cropland and eucalyptus groves extend right to the stone wall boundaries of the park. While poaching for bush meat has been admirably reduced, some still occurs, and tragically, gorillas occasionally have a hand or foot caught in a snare. Fortunately, because of the daily monitoring of the habituated groups, snared animals are usually rescued.

Periodic political instability in the DRC also threatens the mountain gorillas that reside on that side of the Virunga Mountains. There, occasional reprisals for some political offense have resulted in the slaughter of gorillas. It is no wonder that the mountain gorilla is considered a critically endangered animal.

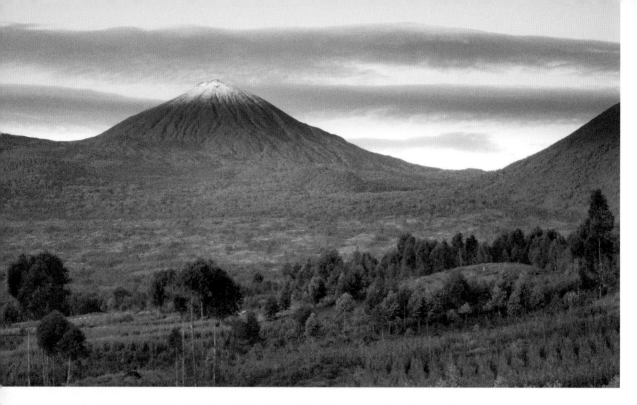

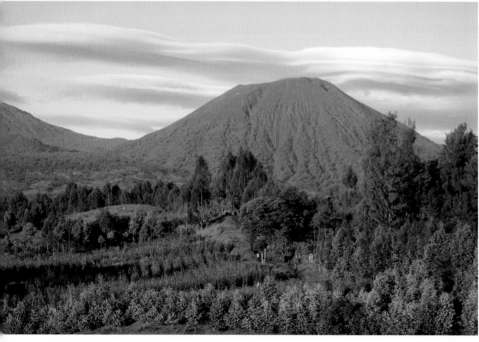

Karisimbi Volcano *(top)*. At 14,787 feet, the Karisimbi Volcano is the tallest of the five volcanoes that make up Volcanoes National Park. The mountain is high enough that, on occasion, the top is covered in snow—a remarkable sight for a mountain near the equator.

Visoke Volcano *(bottom)*. Rwanda's landscape is beautiful, with well-tended farmlands creating a quilt-like patchwork surrounding the park's protected forests.

Mountain Gorilla Family *(top)*. In the 1960s, fewer than 250 mountain gorillas existed. Today, that number has quadrupled, and current estimates suggest that there are now over 1,000. The mountain gorillas, while still critically endangered, are the only species of great ape whose population is increasing.

Feeding *(bottom)*. The protected boundaries of Rwanda's Volcanoes National Park provide a secure home for the numerous mountain gorilla families. There are ten groups that are habituated to humans, for tourism purposes, but other families also roam these forests.

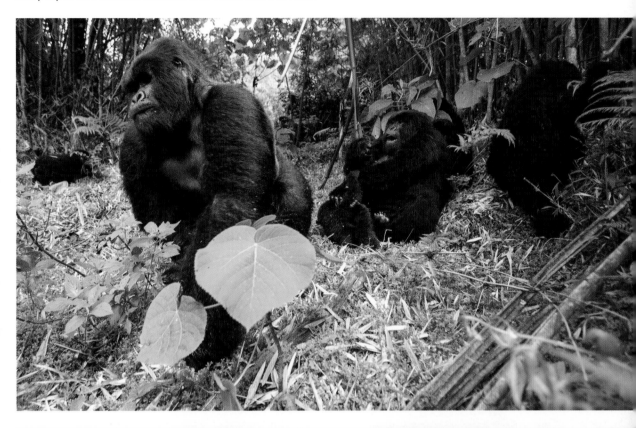

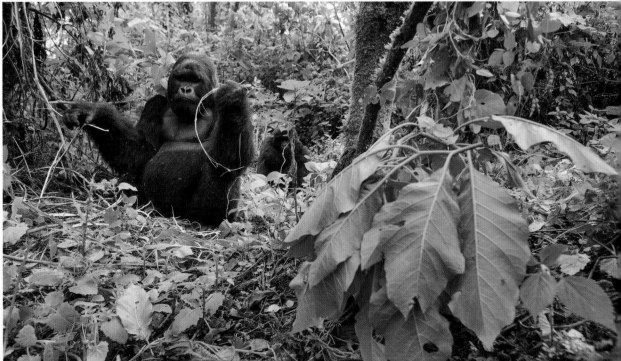

Silverback in Clearing. A silverback sits in a clearing at the edge of a thick bamboo forest. It is a matter of luck as to where a family of gorillas will be on any given day, but on this day we were lucky. The light was soft and this magnificent male was sitting in an opening.

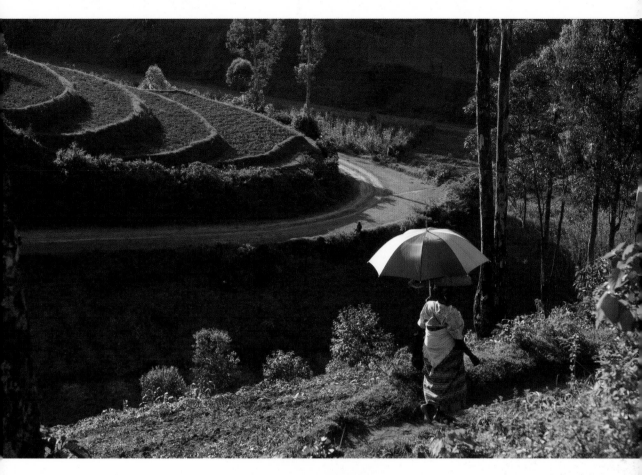

The Terraces *(above)*. Virtually every acre of arable land is used in this mountainous country. Picturesque terraces create man-made contour lines that define the various rows of cropland.

Boundary Fence *(right)*. A tall stone fence, constructed from the lava rock extracted from the surrounding farm fields, marks the park boundary. The fence provides a clear boundary line for humans, and serves as a deterrent for African buffaloes that would otherwise raid the farmers' fields and destroy crops.

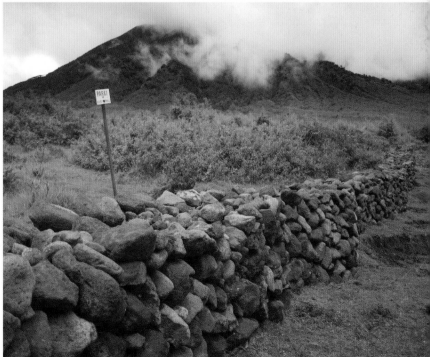

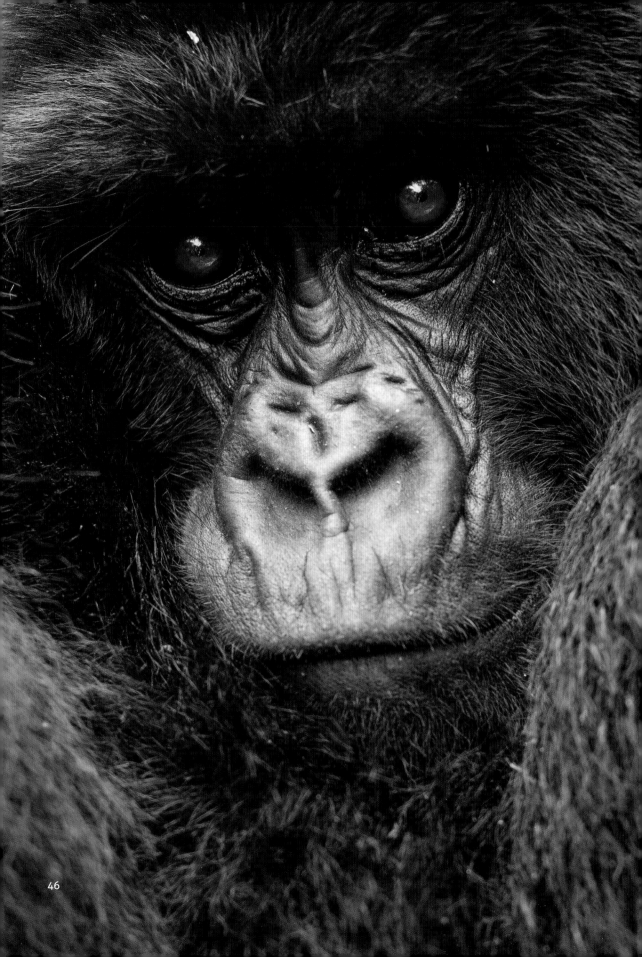

NOSES

With the exception of one or two mountain gorillas in a couple of groups, I must admit that I can't distinguish one gorilla from another. General groupings are fairly easy to distinguish. Silverbacks are unmistakable, as are subadult males, known as blackbacks, because these fairly large gorillas still lack the distinctive saddle of the adults. Nursing females, too, are easy to distinguish, but after that, the two sexes become fairly difficult to discern by the untrained eye. Gorillas lack obvious sexual dimorphism in subadult stages, so telling who's who can be quite a challenge.

Gorilla trackers and guides, on the other hand, know every individual in the family group they follow. Some gorillas might have an obvious scar, or have a missing or injured finger or toe, or a ripped ear, but the forest guides distinguish individuals by the marks found on the nose and the bridge of the nose. Like human fingerprints, these patterns are unique to each individual, and the guides and trackers have no problem distinguishing one gorilla from another.

Mountain Gorilla Portraits *(pages 46-49)*. These portraits of seven different mountain gorillas clearly show some of the many variations in nose patterns used to distinguish one gorilla from another. I'll bet if you show this book to any of the Rwanda park guides, they'll be able to tell you each animal's name! I can't.

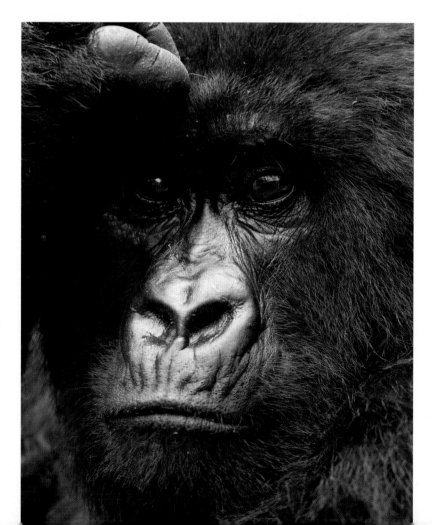

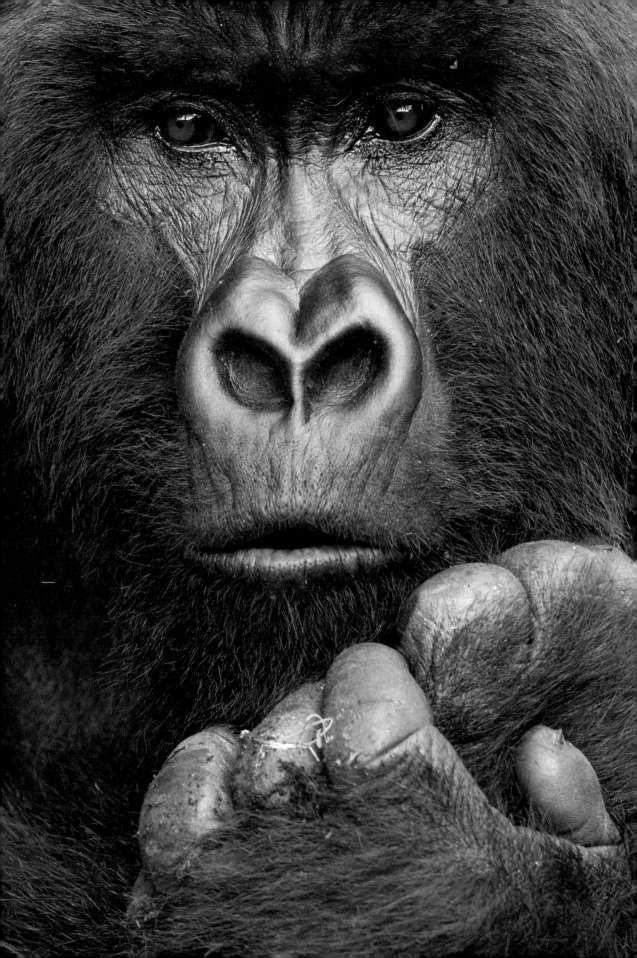

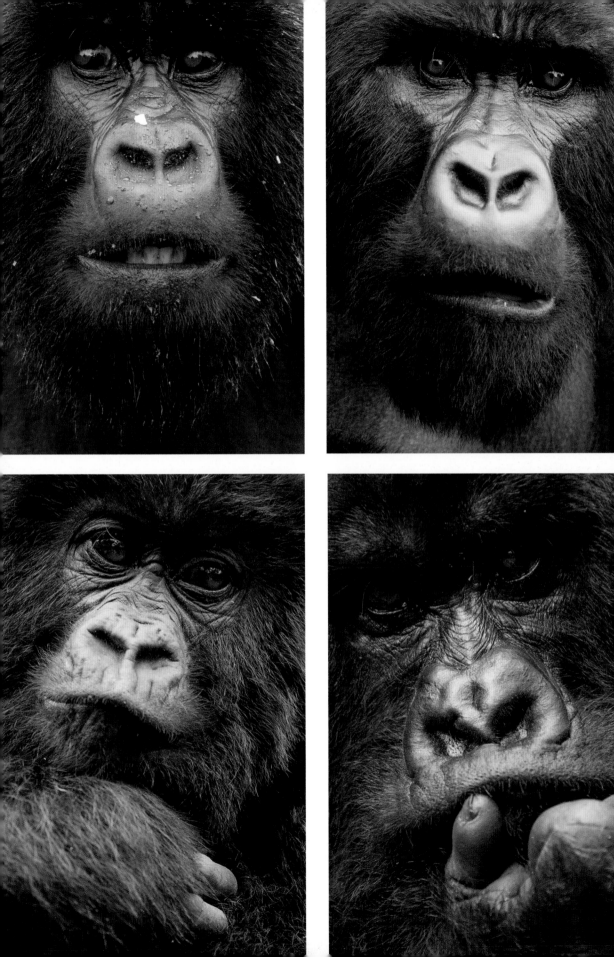

TREKKING

At present, there are ten habituated (accustomed to people) mountain gorilla groups designated for tourism, and several more for research purposes in Rwanda. Habituation doesn't come naturally, and prior to the early 1960s, mountain gorillas regularly fled from the sight or sound of people. It wasn't until the work of George Schaller and Dian Fossey, and the gorilla researchers that followed, that these shy and non-aggressive animals began

Mary and the Park Guides *(top).* The trek starts at park headquarters where, after being assigned a group, the visitors receive a briefing on the gorilla family they'll be visiting.

Park Tracker *(bottom).* Shortly after dawn, park trackers head into the mountains to locate the gorillas, going to the spot where the family bedded down the previous late afternoon. GPS and cell phones, as well as hand radios, have made it far less taxing for the tourists, as the trackers can now direct the guides to the gorillas' present location.

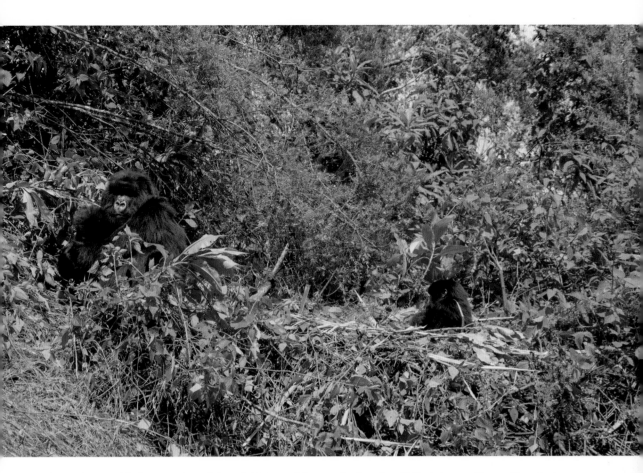

Gorilla Mother and Baby at a Nest *(above)*. If the guides are lucky, they'll find the gorillas still at their nest site. Each evening, females and juveniles make a nest or bed in the vegetation above the forest floor. Nests are used only once.

to accept the humans' presence. Habituation may take a year or more, but when complete, the mountain gorilla family is tolerant to people nearby.

Habituation is not without controversy. Some conservationists and researchers believe there should be no tourist visitation, as this causes a disruption of normal activities, induces stress to the animals, and introduces disease. Others argue that tourist visits, properly done, as I believe Rwanda's are, minimizes these risks, and that the economic benefit derived from gorilla-based tourism far outweighs the risks tourism might impose.

These ten groups may be visited daily, usually with eight tourists per group for one hour with these great apes. The hike to the gorillas may take less than an hour or a good part of the day, depending upon where a particular group is. Once the tourists make contact, the clock starts running, and at the end of the visiting hour, the show is over.

Personally, Mary and I are in favor of this tourism, as our combined 202 treks would indicate. I would argue that for these intelligent animals, these daily visits are a curious break in their routine. Adults are usually blasé and generally ignore their visitors, but young gorillas

often try to interact, which is not permitted and is discouraged by the park guides and trackers. When a young gorilla approaches too closely, a warning grunt or hand gesture shoos the curious animal away, or the tourists are told to retreat. I don't know if the mountain gorillas have a sense of timing or pace, but it is remarkable that at the hour's end, the gorillas often walk off into the forest. Perhaps it is just feeding time, but could it also be that they know that the show is over? Who really knows what they are thinking?

. . . it is remarkable that at the hour's end, the gorillas often walk off into the forest.

The Group Moving Off *(below).* After leaving their nests, the family group moves off to forage. Sometimes a family may move only a few yards before they begin to feed, but just as often, they may move hundreds of yards, or farther. An easy trek in the forest might require only ten or fifteen minutes of walking, but you never know: what was supposed to be a close and easy group might decide to go on a hike of their own, and your trek to the gorillas might require three or four hours or more.

Gorilla Nest and Dung *(right).* Gorillas normally defecate in their nest sometime before departing. These nests, and the amount of dung, allow census-takers to get a fairly accurate measurement of the gorilla numbers, even if some in the group remain unseen.

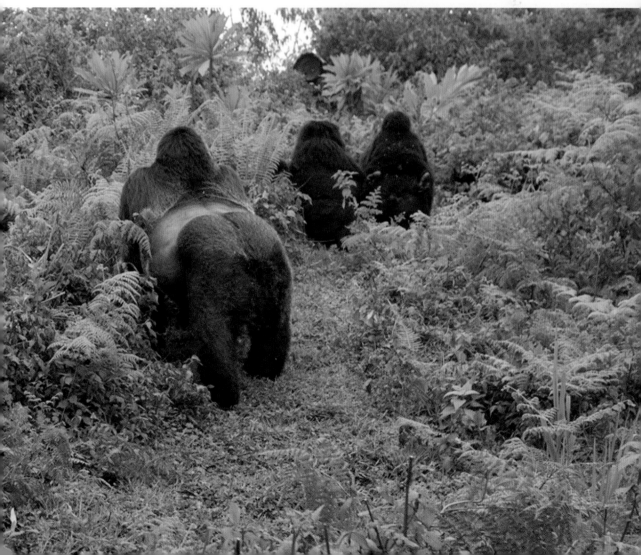

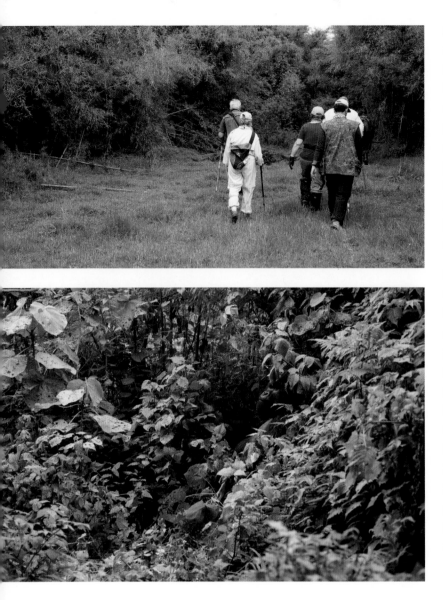

A Trekking Group *(top)*. The actual hike is fairly easy for anyone in moderate shape. One can hire a porter to carry camera equipment or backpacks up the mountains, though the porters do not continue on with the gorillas once the hour begins. Many hikers use walking sticks, available at the start of the hike, to assist in navigating the often-steep trails.

Gorilla in the Bush *(bottom)*. Gorillas are often silent, and their black fur makes them quite inconspicuous in the shadowy areas of a forest. Some treks are less satisfying than others, as the family might be in thick undergrowth, where visibility is restricted, often to brief glimpses of a face or hand. Fortunately, in the course of an hour, there are usually several great viewing opportunities, and rarely does anyone go away disappointed.

Gorilla in the Rain *(following page, top and bottom right)*. The average tourist might hope for a bright, sunny day, but photographers hope for clouds to soften the harsh shadows sunlight creates in a forest scene. Often, a trek is a race with the weather, as the hoped-for clouds build, culminating with a canopy producing great light just as you arrive. It often rains in the late morning or afternoon, and while this makes for uncomfortable conditions, there are interesting photos to be had in this inclement weather.

Bamboo Forest *(following page, bottom left)*. A trek begins in the surrounding farm fields, and then usually ascends through various zones of vegetation, including, in most areas, thick forests of bamboo. Occasionally, the gorillas are found inside these dark, thick forests, where the photography can be extremely challenging.

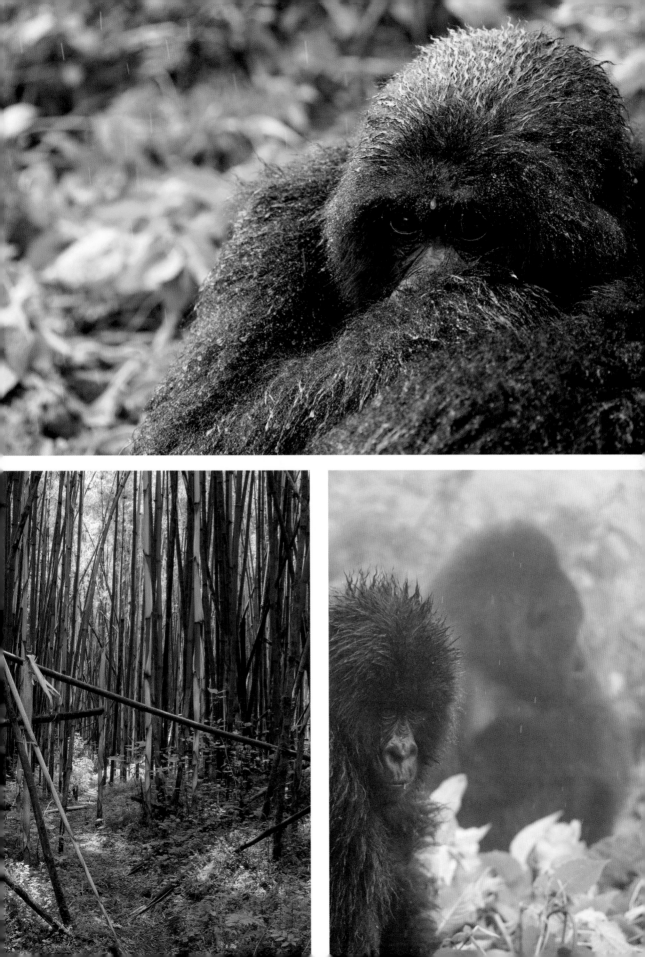

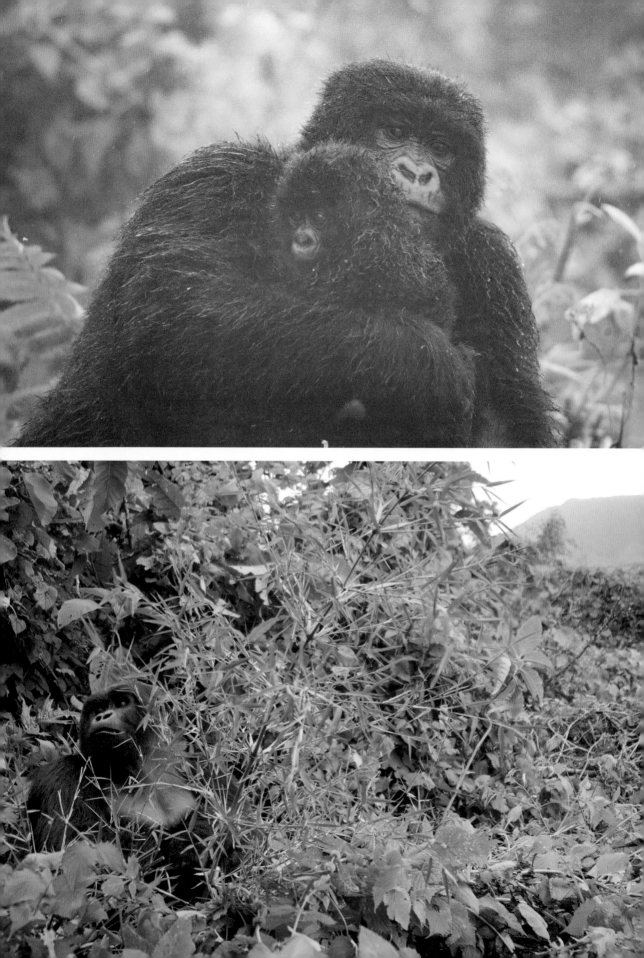

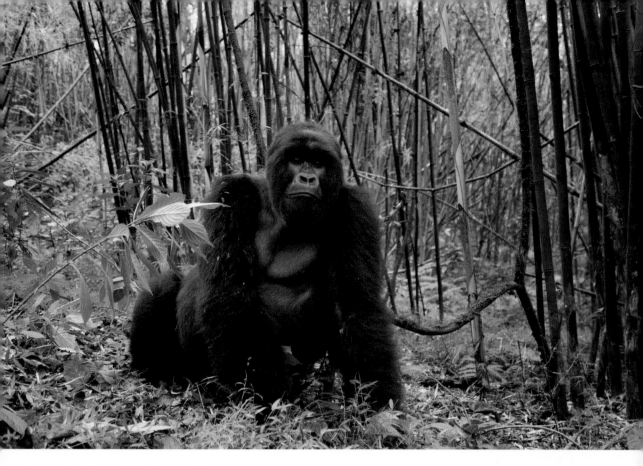

Mother Gorilla and Baby in the Rain *(previous page, top)*. It can be miserable, cold, and wet during or after a rainstorm, and one has to wonder why mountain gorillas chose this habitat to make their home. It seems impossible that a newborn baby, weighing less than three pounds, can survive such taxing conditions, but of course, they do.

Mountain Gorilla and Volcano *(previous page, bottom)*. Although the mountain gorillas live on the slopes of these picturesque volcanoes, it is rare that a volcanic peak and a gorilla are in view simultaneously. Thick vegetation usually obscures the view of any peak.

Silverback *(above)*. Seeing your first silverback calmly resting in a clearing or along a forest trail is an unforgettable experience, and truly one of the most intimate and exciting wildlife encounters one will ever have.

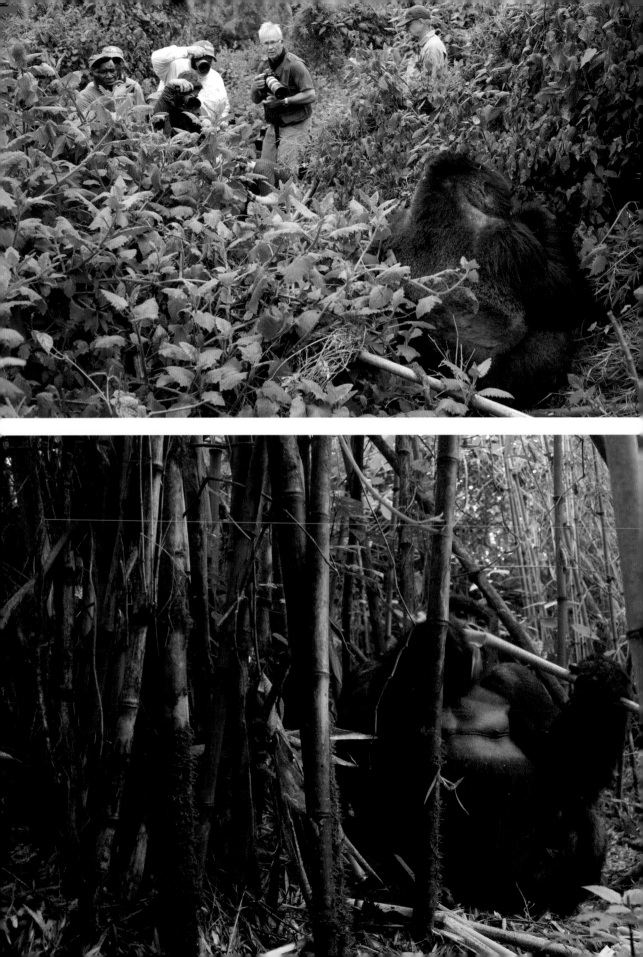

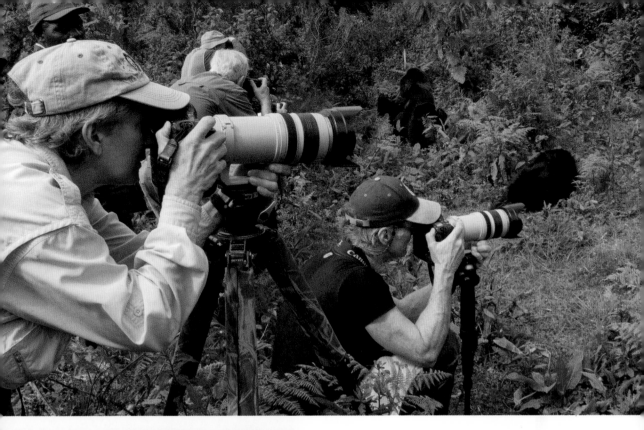

Silverback and Tourists *(previous page, top)*. The hour with the gorillas can be quite dynamic. A family group may consist of only five or six animals, or may number over 30, depending upon the group. The guides and trackers attempt to show each tourist group as much variety as they can, and most tourists get to observe the regal silverback.

Mary and Joe *(above)*. Mary and I once used tripods to support our lenses. Some photographers handhold their cameras, but to ensure the sharpest images possible, especially after scrambling up a steep bank and being out of breath, we use monopods, despite the slight inconveniences they may present. We typically use zoom lenses.

Silverback in Bamboo *(left)*. Digital photography has certainly made image-making a bit easier, especially when gorillas are in a dense stand of bamboo. ISOs can be raised, allowing for faster shutter speeds, but even then, the light can be so dim that making a nice photo is extremely challenging.

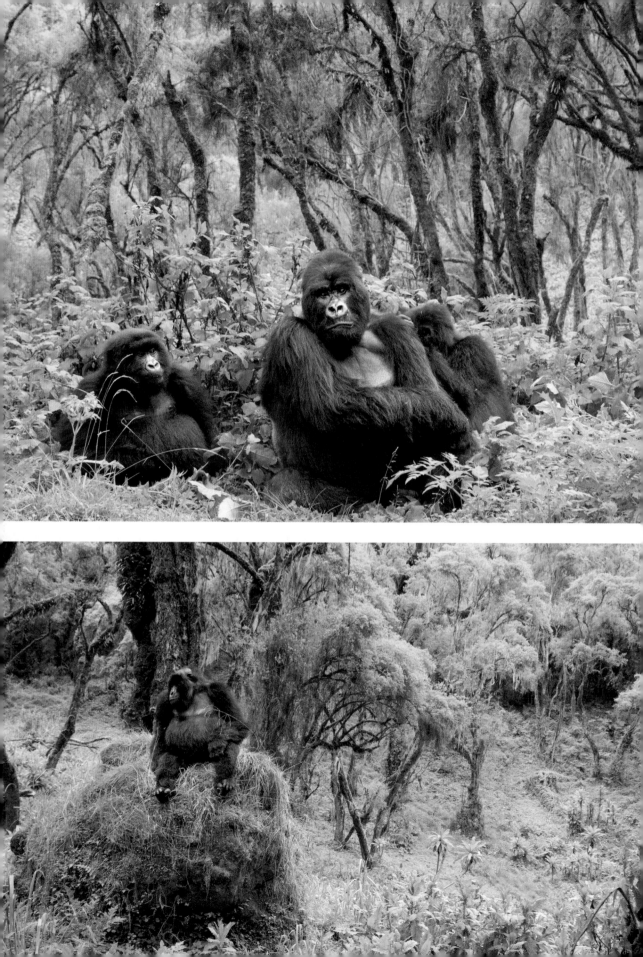

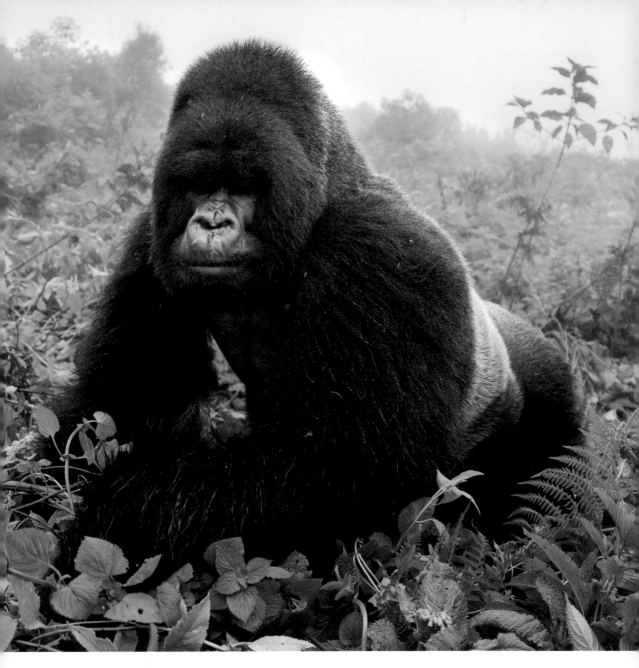

Gorilla Family in the Open *(previous page, top).* In our 101 treks, there are a few locations where we've always hoped to find and photograph gorillas. One of these is a fairyland forest with dripping lichens and mosses carpeting every tree trunk and limb. On one of our treks, a family of gorillas that was in a difficult-to-photograph high brush meadow suddenly chose to descend into this forest. It was magic.

Big Ben *(previous page, bottom).* We've known this mountain gorilla, now a young silverback, since he was only a few years old. Oddly, he has always been bald, making him readily identifiable as "Big Ben."

Silverback *(above).* The highlight of any trek is a great view of a silverback. A large male may weigh 450 pounds. On all fours, surprisingly enough, they may not look very big, that is until they walk on by, when you can really appreciate their massive structure.

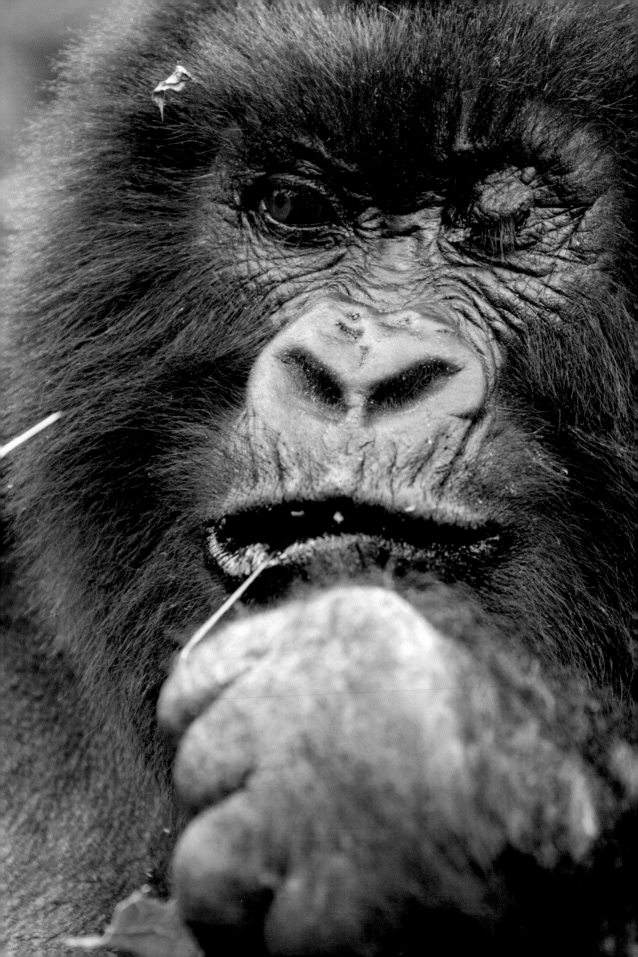

DINNERTIME

Trekkers are generally hiking by 8:30AM, and with any luck, the mountain gorillas will be settled in and either feeding or napping by the time the tourists arrive. Gorillas spend a good part of their waking hours eating. The nutritional value of their diet is low. Consequently, they eat a lot. A silverback may consume an incredible 75 pounds of vegetation every day, while the much smaller female eats about half that amount. Both sexes have what could be called "pot bellies"—big guts to accommodate the volume of vegetation consumed. Gorillas are vegetarians, feeding on at least 140

A silverback may consume an incredible 75 pounds of vegetation every day . . .

A Funny Face *(previous page).* The camera can capture some amusing poses as a gorilla feeds. This female had an injured eye and is likely blind in that eye.

Stripping Bamboo *(below).* Gorillas will spend several minutes, sometimes close to an hour, sitting in one spot and grabbing whatever is edible and within reach. The hard, woody section of the bamboo will be discarded as this silverback strips off those outer layers.

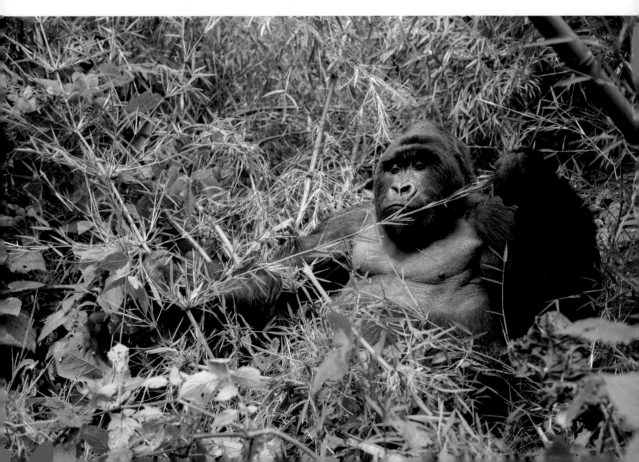

different species of plants, although they occasionally snack on termites and ants.

Favorite foods include bamboo, especially the fresh, soft stalks, and bristly stinging nettles and sharply needled thistles. For a trekker, the nettles are particularly annoying, as any contact with bare skin results in a painful sting that may last for hours. Gorillas eat thistles by grabbing the stalk and stripping the leaves forward, resulting in a handful of leaves whose sharp, pointed ends all face away, wrapped inside the larger outer leaves.

Gorillas rarely drink, but they do occasionally drink water from streams, as we've seen for ourselves. Most of their water requirements are satisfied by the plants they eat. Some guides illustrate this by munching on a stalk of wild celery or thistle, surprising their guests by the volume of water that practically pours out of their mouths. Gorillas do not go thirsty.

Gorillas rarely drink, but they do occasionally drink water from streams . . .

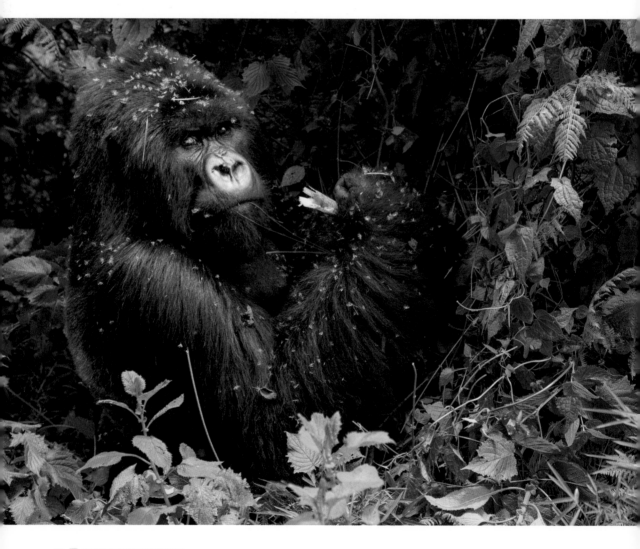

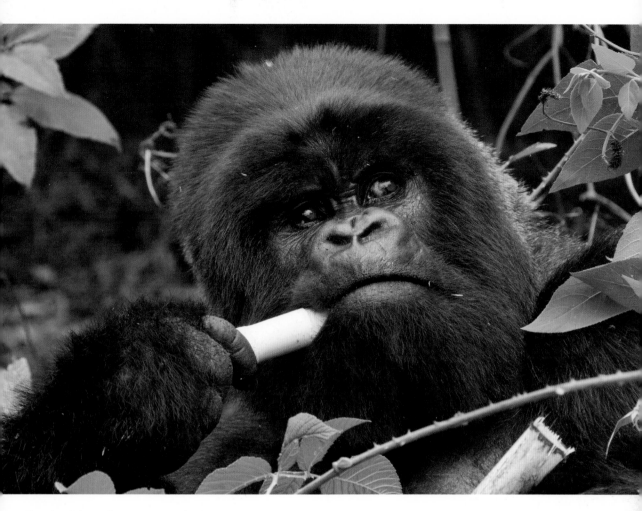

Silverback Leer *(previous page)*. If looks could kill, or at least intimidate, this silverback's glare would certainly do the job. Though his gaze may look menacing, that's just his look; he's presenting me no threat.

Bamboo Stalk *(above)*. Silverbacks are almost incomprehensibly strong, and can snap a three-inch-thick bamboo stem right in half. Typically, a silverback will grab a stem, bending or breaking it in order to reach the tender growth at the plant's tip.

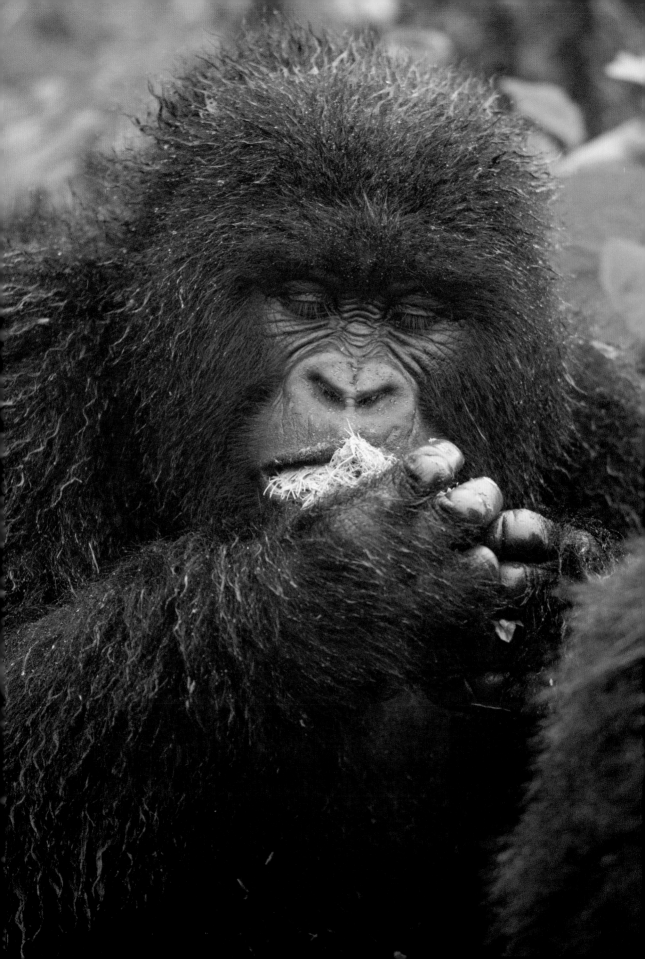

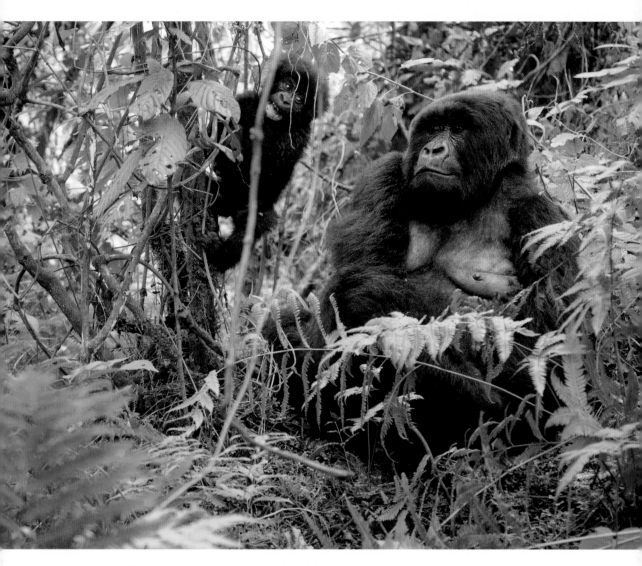

A Less Savory Meal *(previous page).* On occasion, gorillas will eat dung. For youngsters, this might be necessary to introduce the intestinal bacteria needed to digest the plants they eat, and perhaps in older animals, this habit replenishes their gut from time to time.

Gorilla Mother and Baby *(above).* With over 140 plants to choose from, mountain gorillas can feed on the ground and up in trees. Juveniles and young adults are more likely to climb high, while the adults often find food on or close to the ground.

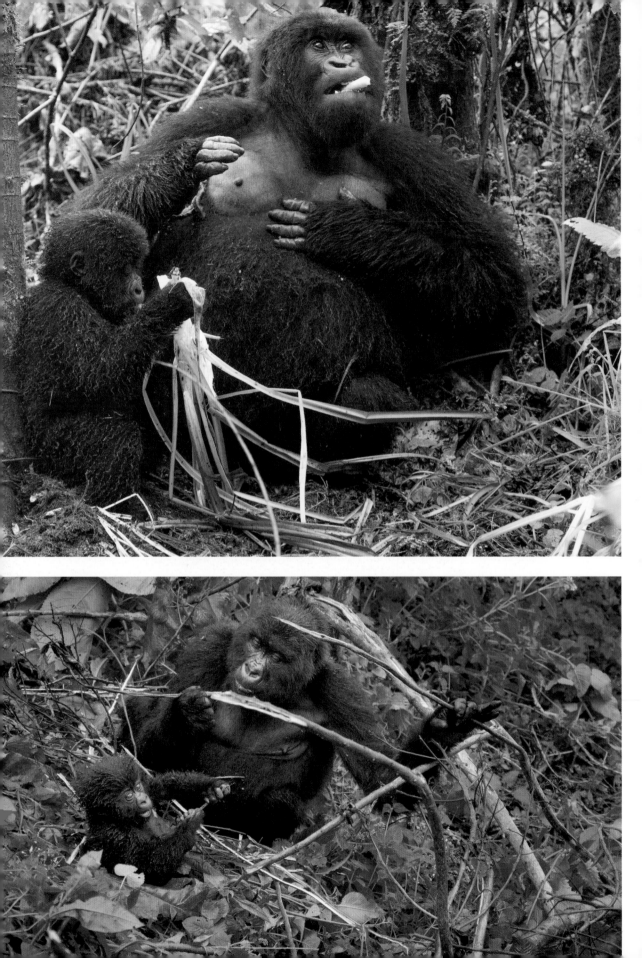

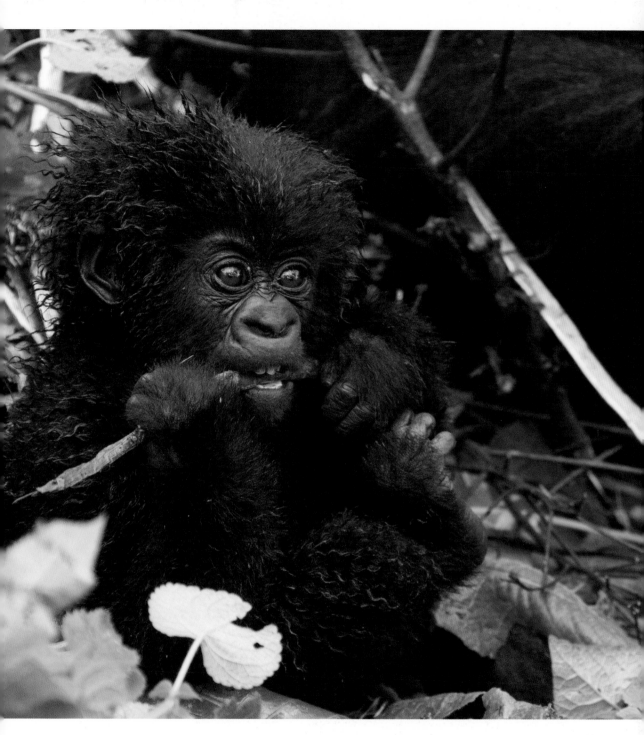

Mother and Baby Feeding *(previous page, top and bottom).* Mother gorillas share their meals with their babies, who also watch and sample anything they see their mothers eating. This sharing is quite amiable, and unlike some mammals we've observed, their meal sharing always seems quite polite.

Baby Eating *(above).* As a baby learns to feed on solids, he experiments—and like a human child, he's likely to put anything in his mouth. This one soon discovered that the woody vine wasn't very tasty.

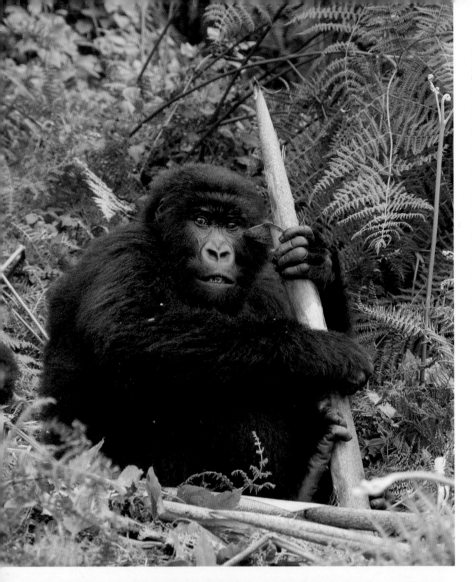

Playing the Cello *(top)*. A juvenile mountain gorilla hugs a bamboo shoot a nearby silverback has discarded, striking a pose that appears as if he's playing a cello.

Baby with a Snail *(bottom)*. Gorillas do occasionally eat invertebrates, but this snail may be safe. It's likely that the shape and movement attracted this young gorilla's attention.

Baby in Tree *(following page)*. Young mountain gorillas often climb trees or bamboo stalks, either to play or to reach tender shoot tips. As adults, they're as likely to simply tear down the bamboo to reach these tasty parts.

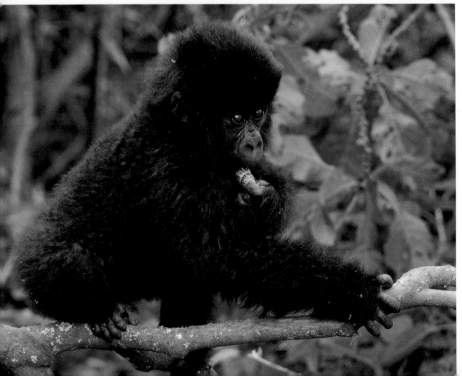

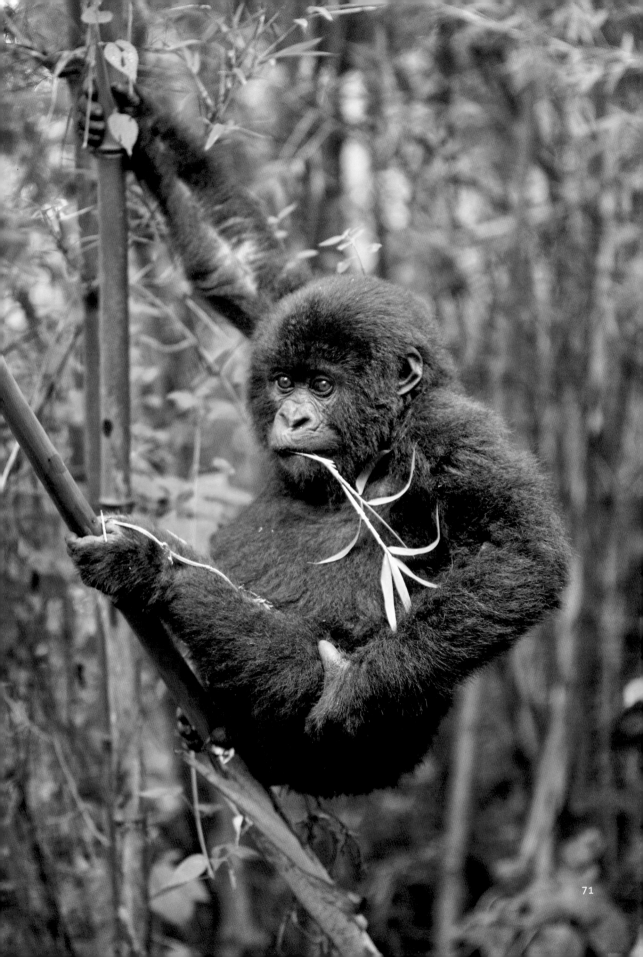

AT PLAY

Humans and mountain gorillas share over 98 percent of the same DNA, so it is little wonder we readily relate to so much of what they do. Like kids everywhere, mountain gorilla youngsters love to play.

The juveniles' playful nature can get them and their tourist visitors in trouble, as juveniles may run, roll, tumble, or stalk up close to a tourist to make a quick and daring slap, prompting a warning grunt from a gorilla tracker and

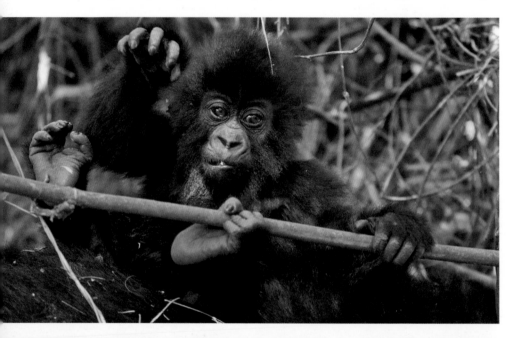

Playing with a Stick *(top)*. Safe upon his mother's back, a baby gorilla wrestles with a thin stalk of bamboo. At this age, he's never far from his mother's side.

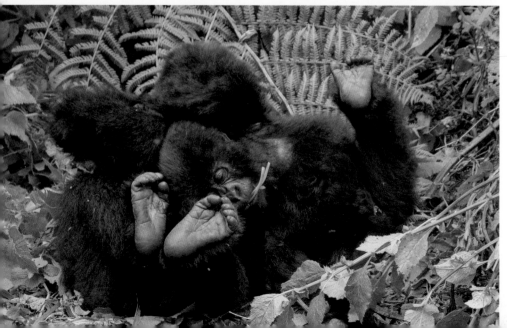

Wrestling *(bottom)*. While it is fun to watch, wrestling gorillas are very difficult to photograph, as they often appear as nothing more than an amorphous ball of black fur. Sometimes, however, they pause long enough that distinctive features are captured.

Juvenile Climbing Bamboo.
Young mountain gorillas
are far more agile than the
adults, and they love to climb
trees. Often, while on a trek,
we've had to duck out of the
way when a bamboo stalk
came swinging down in our
direction, with a young goril-
la delightedly hanging on.

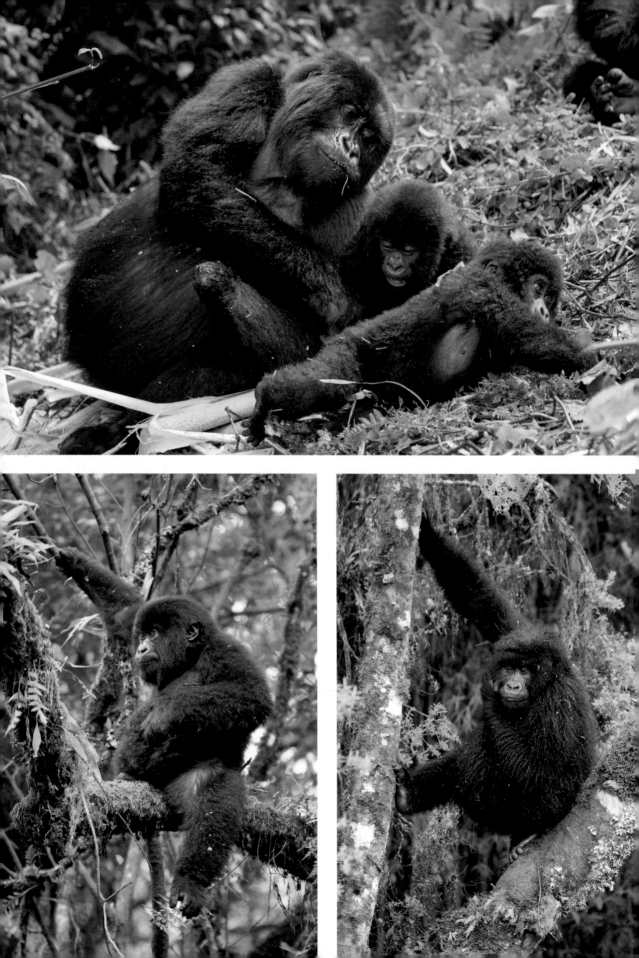

perhaps a verbal command to the tourist to quickly back away.

One mountain gorilla, Shirimpumu, that we've known since he was just two or three years old, was a particular daredevil. He would regularly roll down a hill before rushing in to slap a tripod or monopod or a tourist's leg, before scampering off. As he grew older, he became bolder, and would at times attempt to pull the hapless tourist along, before a guide or tracker scooted him away. As a subadult, he delighted in rushing toward a tourist and sometimes lightly shoving the frightened man or woman as he passed by.

As he grew into a blackback, equivalent to an older human teenager, Shirimpumu became

The One-Handed Mom *(previous page, top)*. If you look closely, you'll note that this mother gorilla is missing her left hand, which was undoubtedly lost after being caught in a poacher's snare. Nonetheless, she has successfully raised babies, and mastered reprimanding them, too.

Out on a Limb *(previous page, bottom left and right)*. Even during their siesta times in mid-morning, juvenile mountain gorillas may climb trees, where they may nap, but are more likely to find some new form of amusement.

Swinging *(right)*. A secure vine makes for an irresistible toy, and young gorillas may spend five or ten minutes repeatedly swinging or spinning, much to the delight of the trekkers. I can relate: as kids, my friends and I did exactly the same thing.

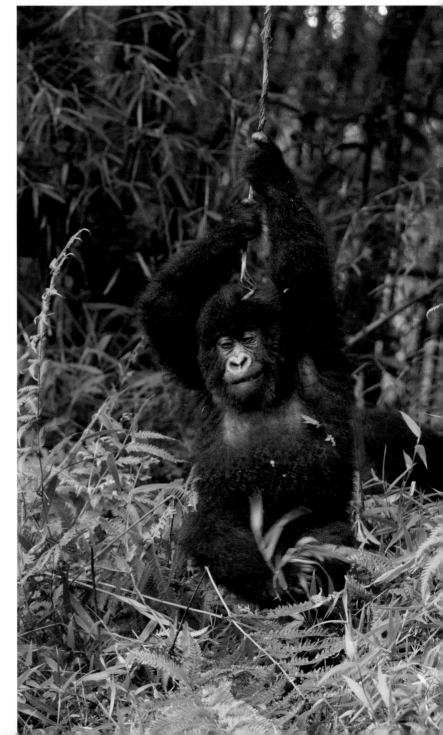

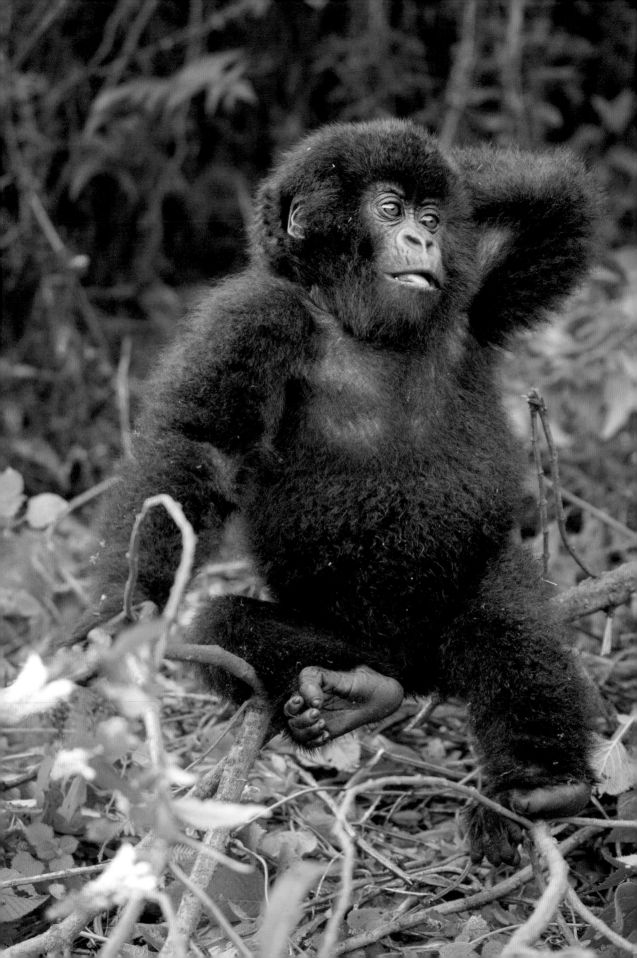

even bolder. We photographed him several times as he charged across a field toward us, looking very menacing, although we knew it was all bluff. Still, I worried if he became the boss of a group whether he'd become a real terror, and potentially make his family group unsafe to visit. Fortunately, that didn't happen; as this mountain gorilla matured, like many a human teenager, he settled down.

. . . as this mountain gorilla matured, like many a human teenager, he settled down.

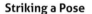

Striking a Pose *(previous page).* Cameras whir as shutters continually fire, due to the fact that the gorilla's expressions and body postures change constantly. This one appears to be striking a classic Hollywood pose.

Challenges *(right).* What one young gorilla does, another will likely do, in a game of follow-the-leader. It is always fun to encounter young gorillas in a family group when they are at play.

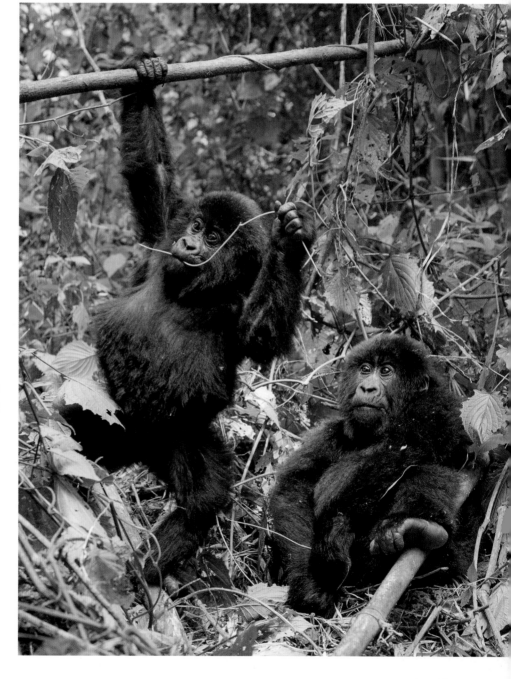

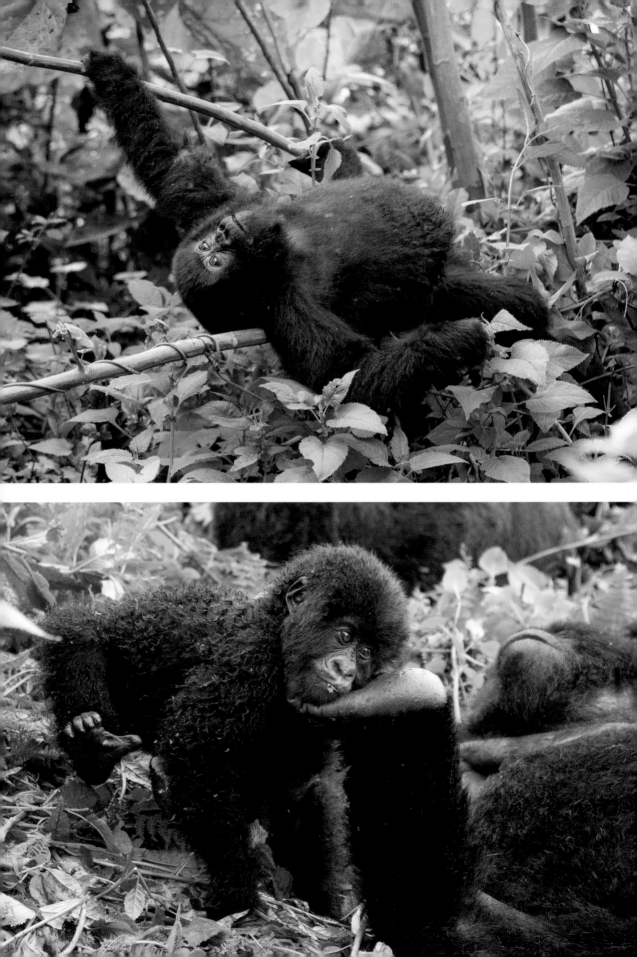

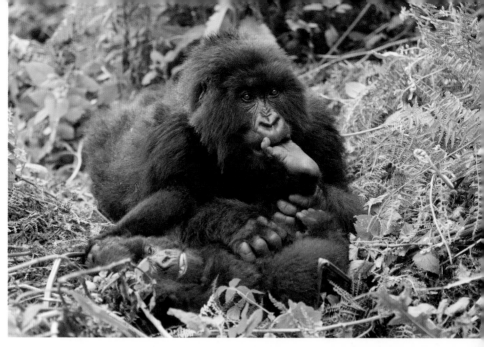

Can't Sleep Right Now *(previous page, top)*. During what is supposed to be the mid-morning rest, mother gorillas will build a crude nest as a make-shift bed. This young gorilla improvised his own little hammock, though he didn't remain there long.

Sole Baby *(previous page, bottom)*. With their dexterous feet, a gorilla has the equivalent of four hands, useful in this case to control the antics of a younger gorilla willing to disturb the nap of an older juvenile.

No Biting! *(top)* A wrestling match may morph into a grooming session or into an intertwined mass of sleepy bodies on a bed of ferns.

Hands and Feet *(bottom)*. We shot a whole series of images as this young gorilla poked his fingers and toes into the air or slapped the palms of his hands and soles of his feet together.

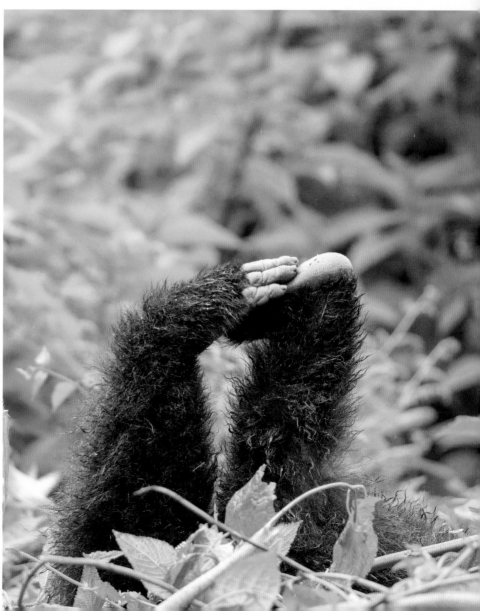

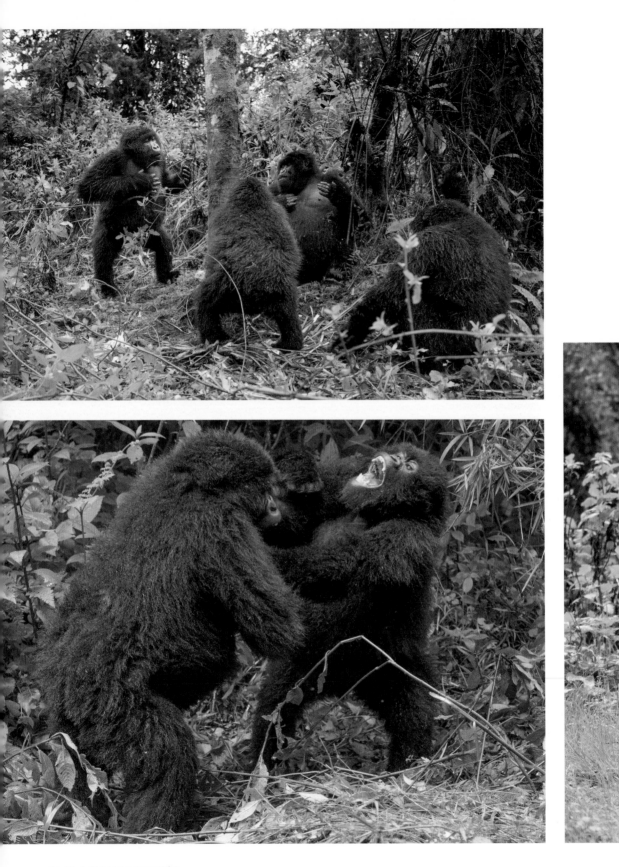

Rock Band or Politician? *(previous page, top)* We were entertained for minutes by this group of juveniles. In this shot, I could imagine the group is at a political meeting, or perhaps they're just playing air guitars.

Harmless Play *(previous page, bottom and below).* Some wrestling matches may look very rough or serious, but it is all in play. As is the case with human teenagers, the roughness may escalate as the youngsters grow older. Still, these tests of strength establish a pecking order and, for the victors of these matches, a sense of confidence which they'll need as adults if they wish to be masters of their own family groups.

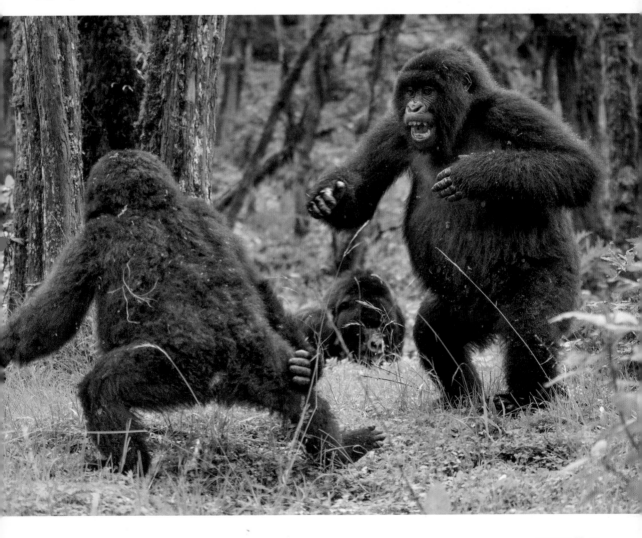

You Got Me! Sometimes a baby will just fall back into the cushioning vegetation, reminding me of a kid playing cowboy and losing in a gunfight. The sheer joy of their antics always makes our fellow trekkers laugh.

Feeling His Oats. This is Shirimpumu, whom we fondly referred to as "the crazy one." While on this trek, he regularly charged across an open field, causing unnecessary fear in some trekkers. Mary and I thought it was fun to watch, but we observed some wide-eyed tourists when this subadult went rushing by.

Nursing Mother. The matted fur of this baby's head and the curly-looking fur of his mother are the result of a heavy rain. At 8,000 feet or higher, a soaking rain can be chilling or downright cold, and I'm always amazed to find healthy, tiny infants in their moms' arms after a pounding, overnight down-pour.

FAMILY LIFE

Mountain gorillas live in family groups comprised of one or more silverbacks, one or more females, and the juveniles and babies belonging to those females and fathered by the dominant silverback. Though each family group has one silverback who is the undisputed leader, some groups have several silverbacks, brothers or older sons of the boss. In one of our favorite groups, the oldest and once the largest silverback, Guhonda, was eventually replaced by one of his sons, who tolerated the old man and allowed him to remain in the family group. It was sad to see Guhonda as a displaced patriarch who once was the undisputed ruler of his kingdom.

Silverbacks, as they mature, must leave their group if they wish to start their own family . . .

Silverbacks, as they mature, must leave their group if they wish to start their own family, and these males stalk the jungle, intent on

Silverback *(below)*. The dominant silverback in a group appears aloof, sitting or lying down by himself, secure in his position as master of his family.

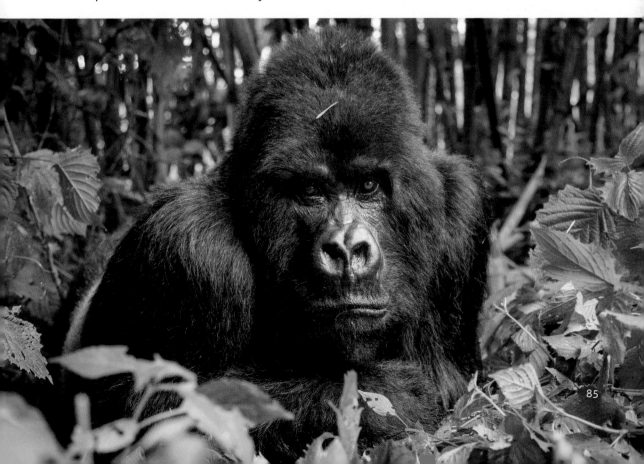

85

stealing females from other groups, or they may challenge a resident silverback to claim his entire family. Neither approach is tolerated, and silverbacks will vigorously defend their females, sometimes resulting in violent clashes that end in serious injury or the death of one of the combatants.

Females are not passive participants in mate selection. Young, breeding-age females may sneak off on their own for a time, likely in hopes

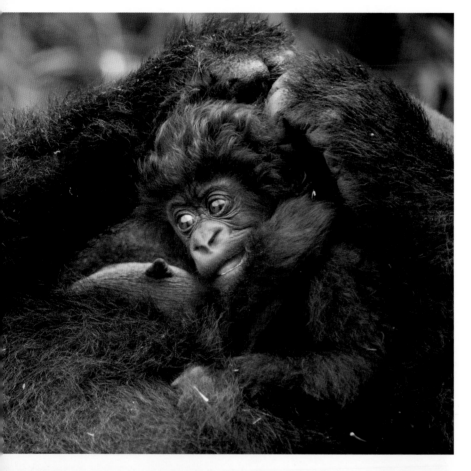

Baby with Mom *(top).* The length of pregnancy in mountain gorillas is virtually identical to that of humans, being nine months in both. Birth weights differ, however, with baby gorillas weighing in at about 3.5 pounds, as opposed to the average 7 pounds or so for humans.

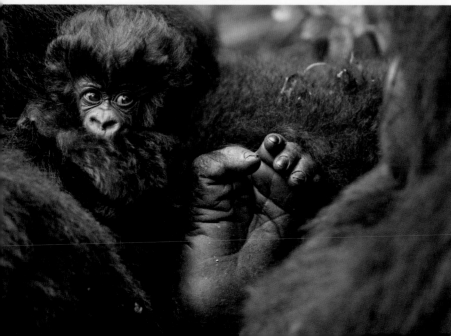

Baby and his Mother's Foot *(bottom).* The ratio of birth weight to adult weight is quite different between mountain gorillas and humans. A 3.5-pound infant gorilla may weigh 400 pounds or more as a mature silverback, over 100x its birth weight, while a 7.7-pound human baby's average U.S. adult weight is just shy of 200 pounds, only a 25x increase!

Mother and Infant. For their first two years, mother gorillas keep close tabs on their babies, nursing them for around 2.5 years. Unlike human infants, however, baby gorillas develop motor skills quite early, and are capable of crawling by around two months.

of meeting a new male. As with people, some gorillas just don't get along, and, given a chance, one of the females in a group may go off with a challenger if she can slip away. By pairing up with a new male just starting his own family group, it is possible that the first female may acquire special status, just as occurs in other primate societies, including polygamous human ones!

An unsavory but not atypical consequence of an actual takeover, where the resident silverback is displaced, is infanticide, ensuring that any babies in the group are the new boss's. That said, in an established family, there is a great deal of nurturing and tolerance of the young. A resting silverback can be swarmed by his sons and daughters who play upon his back, jump on his head, and use his huge body as an obstacle as they play chase or wrestle. Mothers are a model of maternal love and devotion, making the time we spend with a family the most treasured of our experiences.

. . . in an established family, there is a great deal of nurturing and toleration of the young.

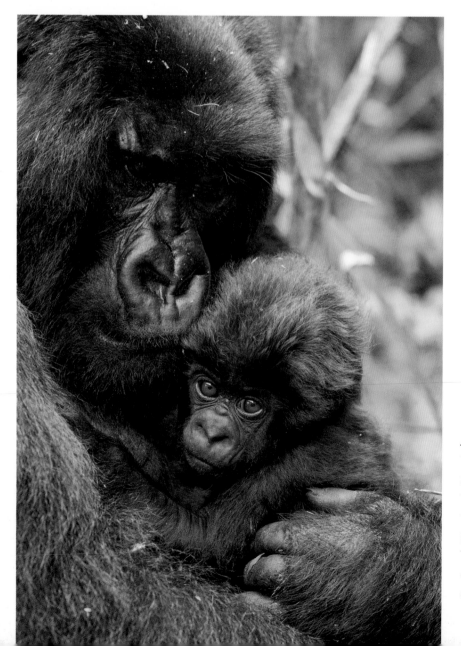

Unruly Mops *(left and following page).* Very young baby mountain gorillas sport an unruly tuft of hair, disproportionately long in comparison to the adult's. Their unruly mop can contribute to some endearing images.

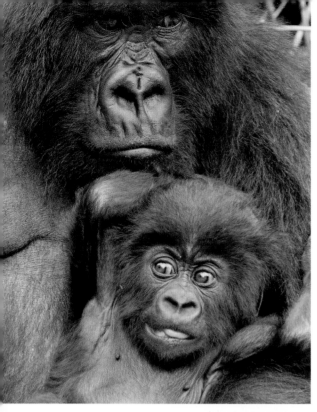

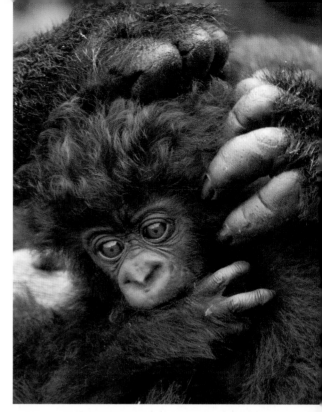

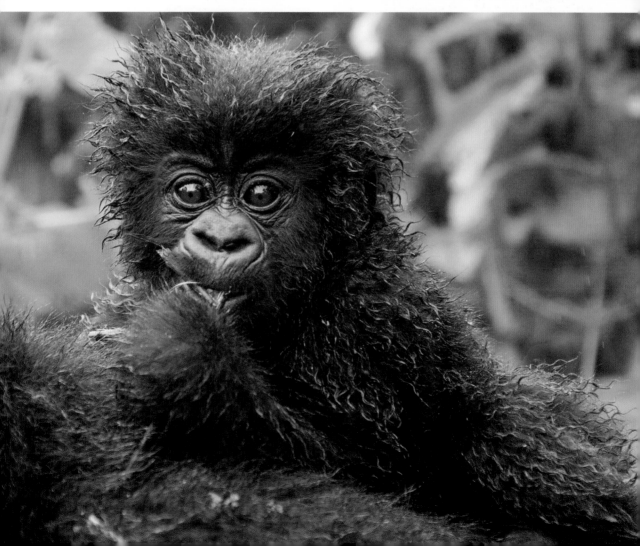

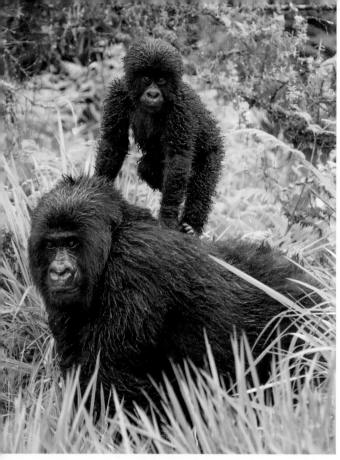

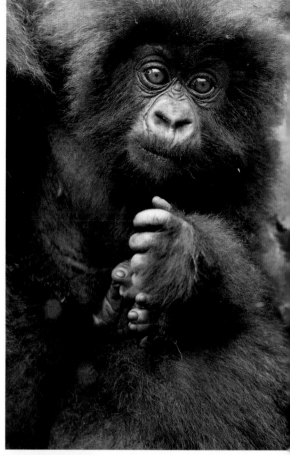

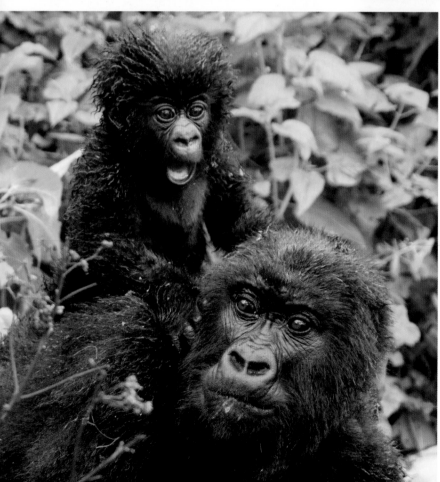

The Jockey *(top and bottom left)*. Baby mountain gorillas regularly ride on their mothers' backs when they're old enough to do so. Newborns cannot, and their mothers must devote one arm for securing their infant beneath them. Although gorilla twins occasionally are born, they very rarely survive, as two infants are difficult to carry.

Looking Curious *(top right)*. As toddlers get older, they begin to explore the world, meeting their cousins and aunts, the silverbacks, and the many interesting diversions they'll encounter in the forest.

Hopping Aboard *(top).* Although a baby may climb aboard his mother, when she is ready to move on, a mother will often reach back, grab the baby's arm, and swing the infant onto her back. Once there, the baby may sit upright, if old enough, or just hang on while lying on her back.

Man-Handling *(bottom).* Babies are flexible, and a mother's matter-of-fact repositioning of her baby might seem callous, but the baby is never harmed, and rarely complains vocally at any perceived inconvenience.

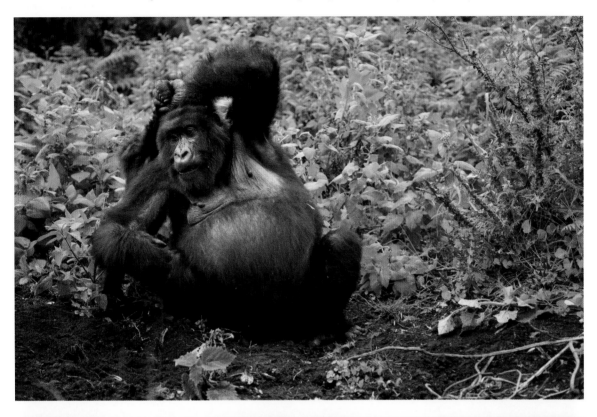

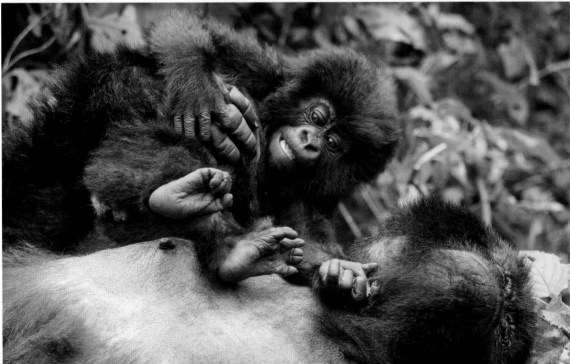

Baby Hanging. Fortunately, the days are long gone when reputable zoos around the world would accept infant gorillas brokered by some animal dealer. Mothers, and especially silverbacks, are fiercely protective of their families, and for anyone attempting to steal a baby, the cost was the death of several other adult gorillas. The boss silverback, and perhaps his subordinates, and the baby's mother might all be killed in the effort to steal a baby.

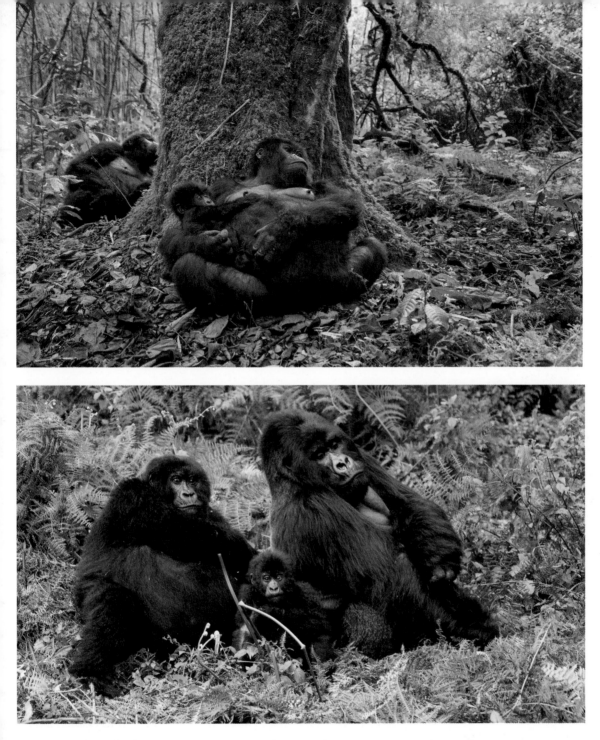

Mother and Baby *(top).* Legally protected throughout their range, it is extremely rare for anyone to attempt the poaching of a baby mountain gorilla today. The western gorilla, however, does not enjoy the same commitment for its preservation, and hundreds, if not thousands, are killed each year as "bushmeat" for human consumption.

A Gorilla Family *(bottom).* The classic nuclear family, with mom, dad, and baby. In this case, though, the silverback may have several other "wives" in the undergrowth nearby.

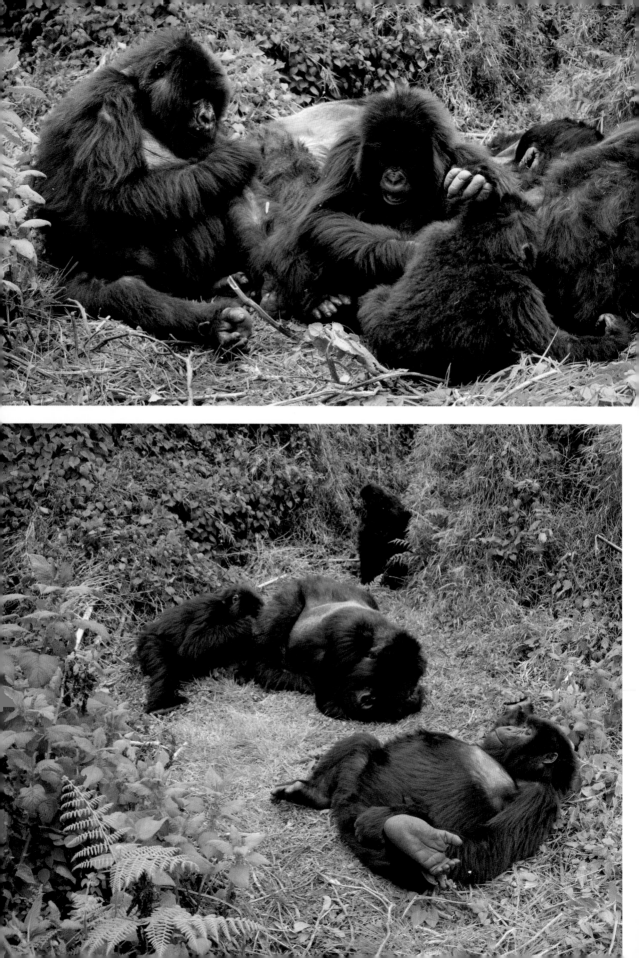

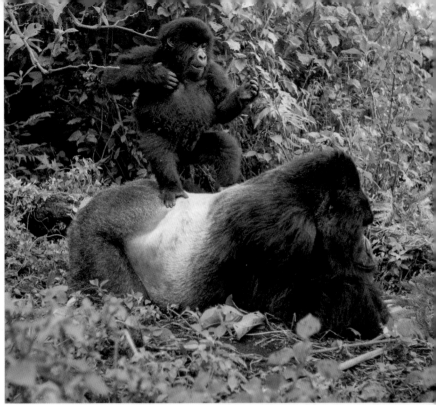

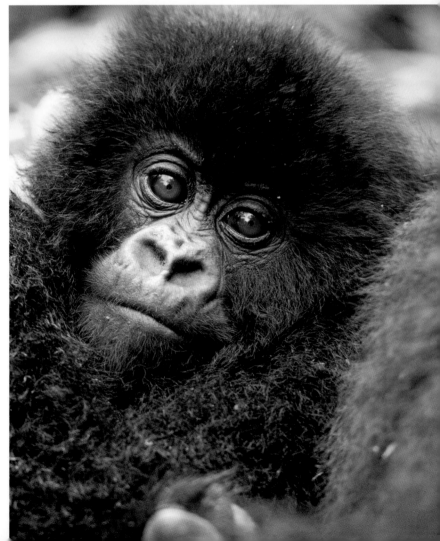

At Rest *(previous page, top and bottom)*. During their mid-morning break, the entire family may lounge about, the adults either sleeping or idly grooming one another, while the young are likely to be playing nearby.

King of the Mountain *(top)*. Mimicking dad, a young mountain gorilla beats his chest while standing atop his role model. Silverbacks are amazingly tolerant of their young, and if annoyed, simply walk off to a more peaceful resting place.

Baby Portrait *(right)*. A three-year-old stares at the camera. Youngsters are far more likely to make direct eye contact, something adults rarely do, as a direct stare is often a sign of aggression. Young gorillas are merely curious.

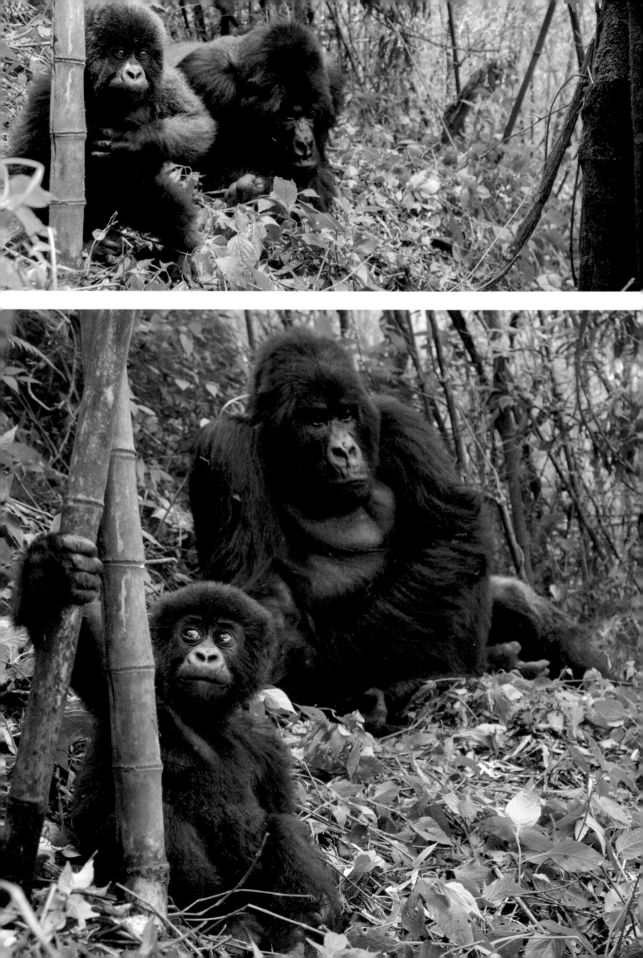

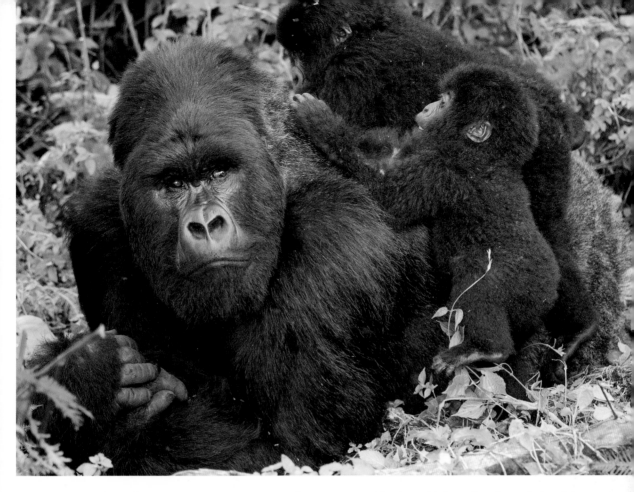

Under Watchful Eyes *(previous page, top and bottom)*. Mountain gorillas have little to fear from their wild neighbors. Lions do not live in their forests, and leopards, if present, are very rare. Nonetheless, a seemingly oblivious silverback would be instantly alert should any form of danger threaten his group.

The Neatest Toy *(above)*. Two young gorillas use the broad back of their father as the perfect launching point for a slide-down or a body roll.

Proud Father *(right)*. At rest, a silverback may lay sprawled out on his back or flat on his belly, with his head cupped in support as he gazes at one of his offspring.

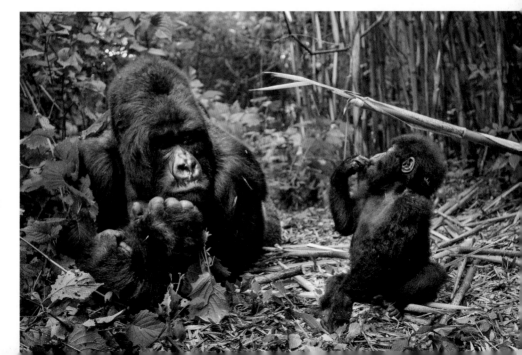

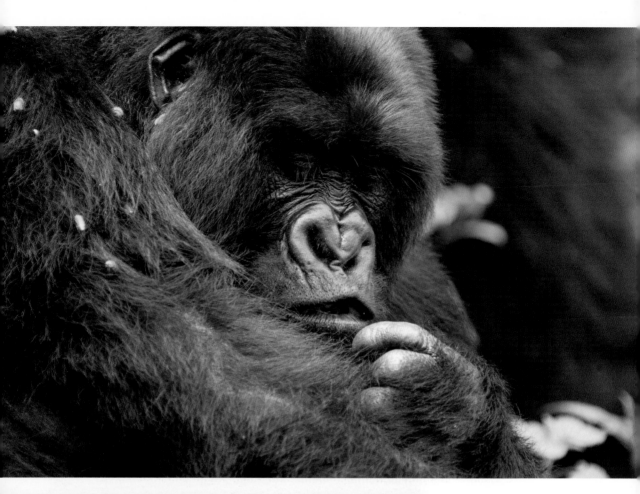

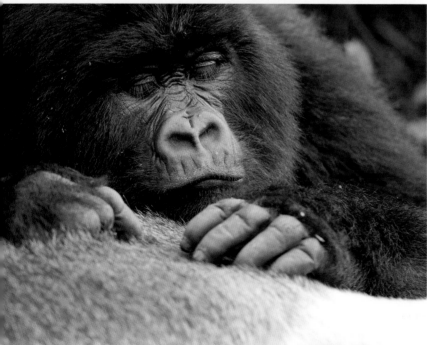

Grooming *(top)*. Gorillas spend a portion of their day tending to their fur, and two or three may join together to mutually groom. Most primates do likewise, although some, like baboons and chimpanzees, may groom one another to form status-seeking bonds.

Grooming the Silverback *(bottom)*. Gorillas almost always look well-groomed, with fur that appears unmatted and clean. Parasites, like ticks or fleas, may be uncommon in the forest, but any that are present are attended to and removed.

Checking Things Out *(top)*. While the silverback is the undisputed boss, gorillas may scatter and be out of sight of one another while they rest or feed. Should they need to assemble or move off, vocalizations will signal that intent.

At the Playground *(bottom)*. Like two human mothers at a playground, these two females take a momentary break while one of their young plays on a tree. Who cannot relate to this scene?

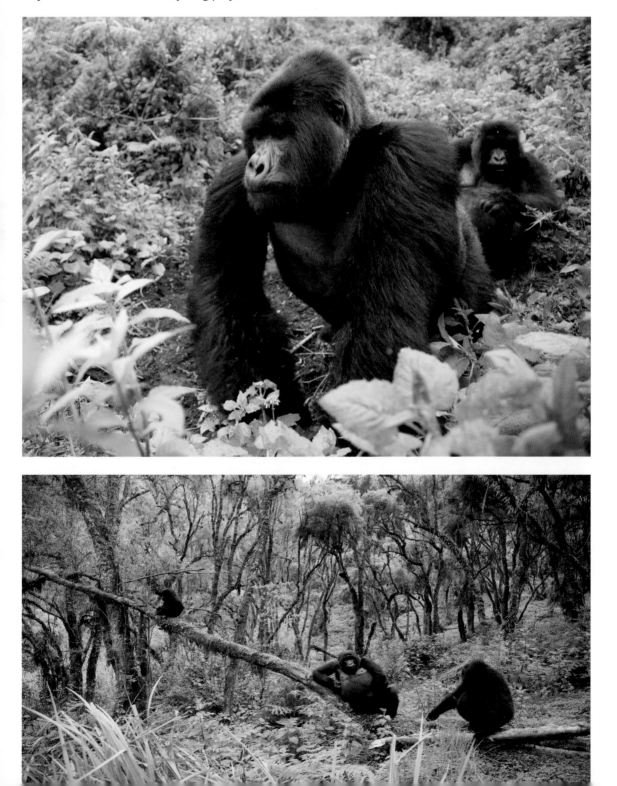

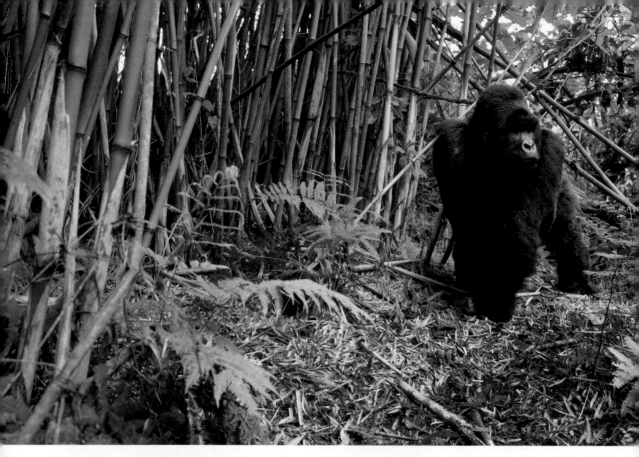

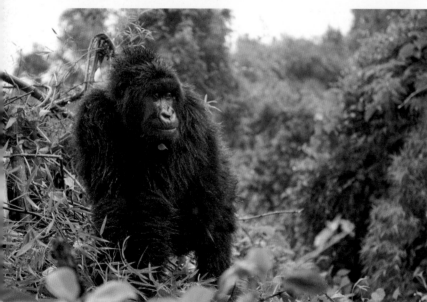

Silverback in Bamboo *(above)*. On any given day, a gorilla family may forage in a forest of bamboo, in a meadow of thistles, in the lichen-covered forest, or outside the park boundaries in the neighboring farm fields. Each trek is different, and one never knows what he or she will encounter.

In the Wet *(left).* During the rainy season, it rains a lot, sometimes all day, often starting by mid-morning. In heavy rains, gorillas may take shelter in the trees and huddle, miserably enduring the weather, if such cover is available. Otherwise, they may simply carry on.

At a Forest Stream *(this page)*. These three shots may be among the most unique images we've taken. Gorillas get most of their water requirements from the plants they eat, and are reported by many sources to avoid water, or getting wet, whenever they can. After a heavy rain, this small ravine filled with water, and most of the subadults explored the newly formed pools. Gorillas drank water either from their fur, after dipping their hands into the water, or by leaning down and lapping—something I didn't think they could do. In the 30 minutes at the pools, the gorillas were actively engaged, often slapping the water to make big splashes, or slamming small logs into the pools to do the same. It was a very exciting time for us to document these behaviors.

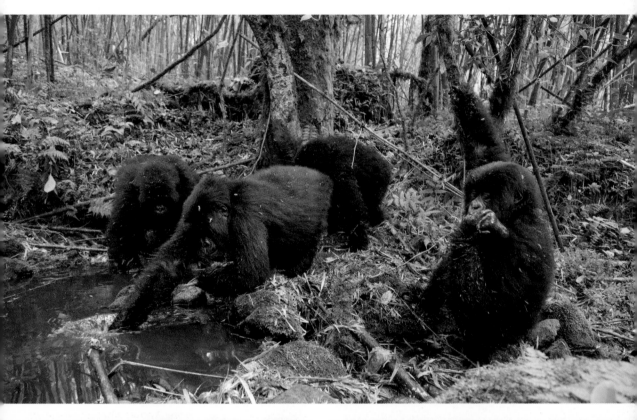

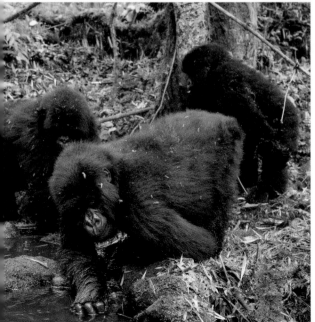

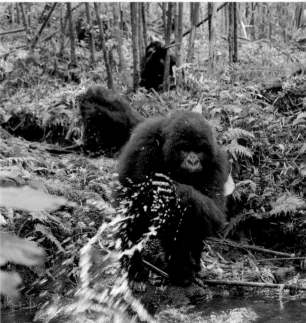

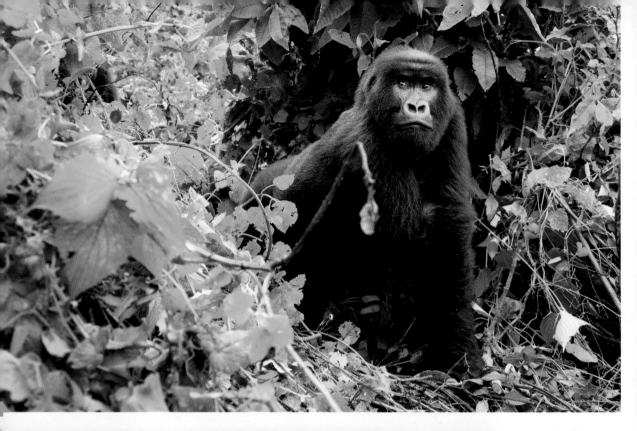

Assessing His Horizons *(above)*. This blackback will soon acquire the distinctive silvery-white saddle of the adult silverback, and at that time, he may choose to remain within his family group or he may leave his family in the hopes of acquiring his own.

A Powerful Chest *(above)*. A naïve tourist might believe that the huge, pot-bellied gut and saggy-looking chest are signs that a gorilla is out of shape. That conclusion will soon be corrected when one observes a gorilla in motion, effortlessly racing up a steep mountain slope or tearing down a bamboo tree as thick as a 2x4 and snapping it in half.

Silverback. Large family groups may have over 30 adults, with several silverbacks as part of the group. These silverbacks may be brothers of the leader, or his sons. Either way, in a large group, there is a definite advantage in having powerful allies that can protect the family unit from rival families intent on stealing away females.

Contemplation *(this page, following page).* With at least 140 different species of plants to choose from, an easy meal is always close at hand. Consequently, gorillas can afford to spend a good deal of their waking hours comfortably relaxing, or grabbing a snack that's literally an arm's length away.

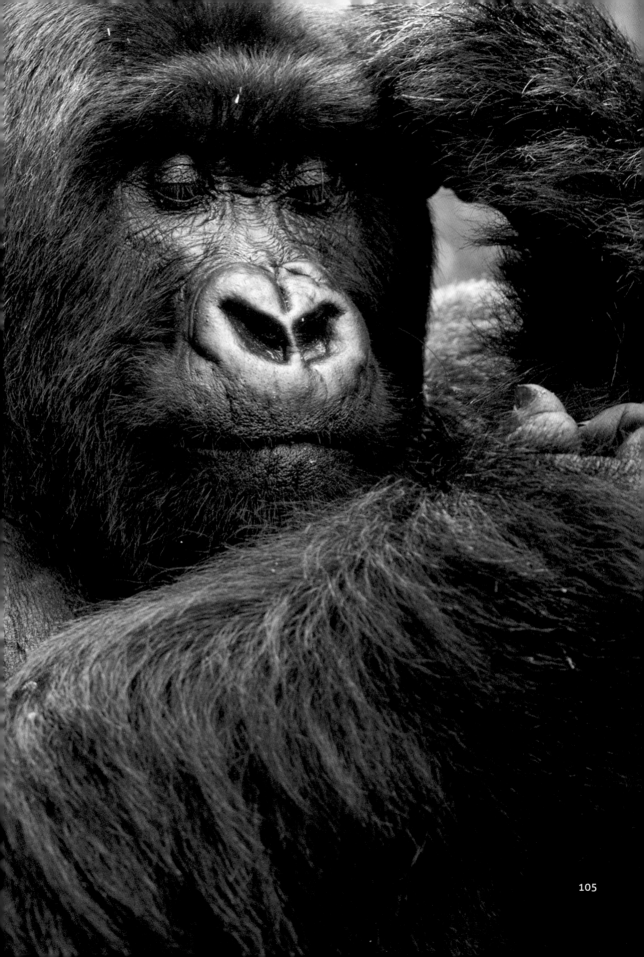

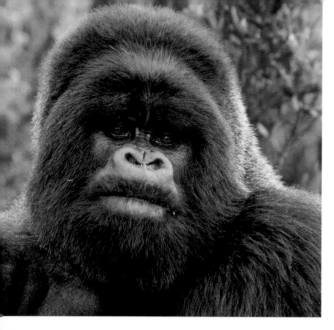
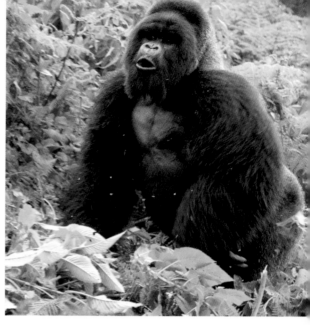
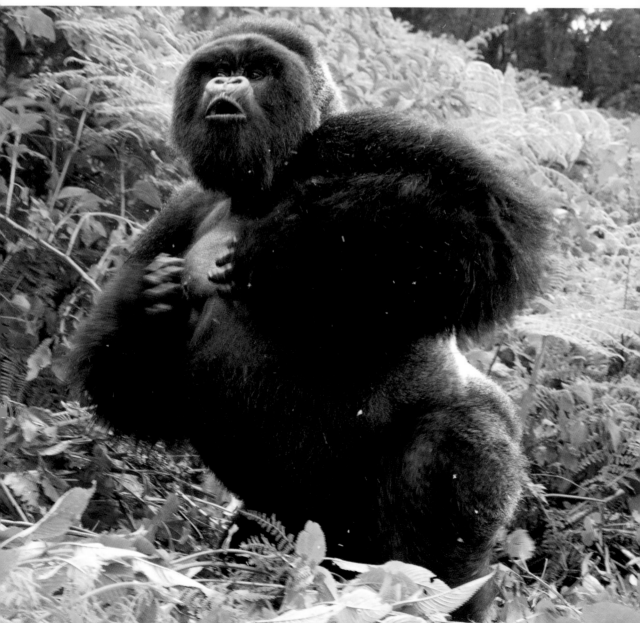

CHEST-BEATING

The drum-like "pok-pok-pok-pok" thud of a mountain gorilla beating his chest is simply thrilling, encapsulating the very essence of the mountain gorilla and its environment. Echoing through the forest, its source unseen, the beat evokes mystery and any romantic notion one may have of this intriguing creature. I simply love that sound!

Most everyone mimicking this chest-beating does so incorrectly, pounding their chest with clenched fists. Gorillas slap their chests with open palms. Typically, a silverback stands

The Tell-Tale Signs *(previous page)*. Silverbacks usually signal an imminent chest-beating by puffing out their upper lip, which is also a sign of annoyance. This may be immediately followed by puckered lips as the gorilla emits a series of rapid hoots. Within seconds, the silverback rises up on his legs and runs, slapping his chest as he does so.

The First Charge *(below)*. Every photographer has their dream shot, and I really wanted to capture a chest-beating charge of a mountain gorilla. As is so often the case, being successful means being in the right place at the right time and being lucky.

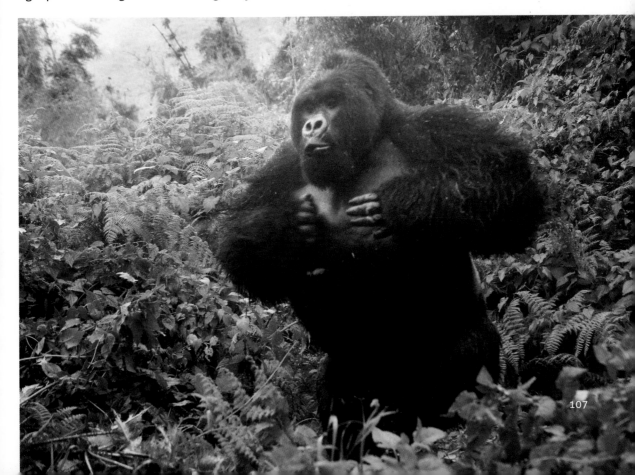

upright and runs a short distance as he slaps his chest. Juveniles, including fairly young gorillas, also beat their chests, often while standing upright but skipping the running move of the adult. Females occasionally beat their chests as well, usually while sitting, and I've seen adults of both sexes doing so while lying on their backs, but in these cases, the chest-beating seemed desultory, almost as an afterthought.

Why do they do it? For silverbacks, at least, chest-beating may be a proclamation of vigor, status, dominance, and intimidation. Sometimes, when two groups forage uncomfortably close but still out of sight in the thick forest, silverbacks will chest-beat to announce their presence, doing so perhaps as a warning to the other family group to keep away.

Showing Off *(below)*. We've seen both sexes and all ages beat their chests for no apparent reason. Silverbacks, however, are believed to do the full chest-beat/run display as a show of dominance, strength, intimidation, or discipline. He usually makes his point.

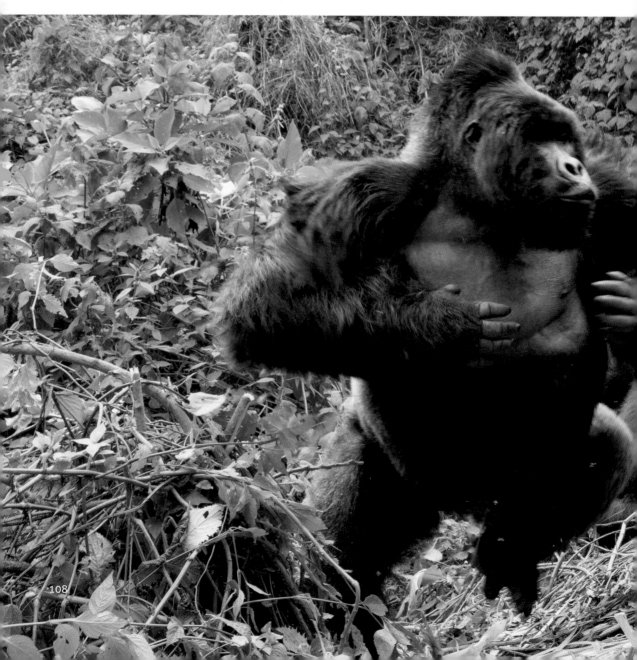

Chest-Beating Run *(top).* We were lucky enough to encounter a family in an open meadow, and the male obliged us by standing and running about 40 feet before settling back onto all fours. He ran within a few feet of one of our human friends, who had turned away and missed the entire display!

A Near Miss *(bottom).* Though I knew a display was imminent, I almost missed this shot. Fortunately, muscle memory came into play, and I pressed the right buttons and caught this silverback when he performed.

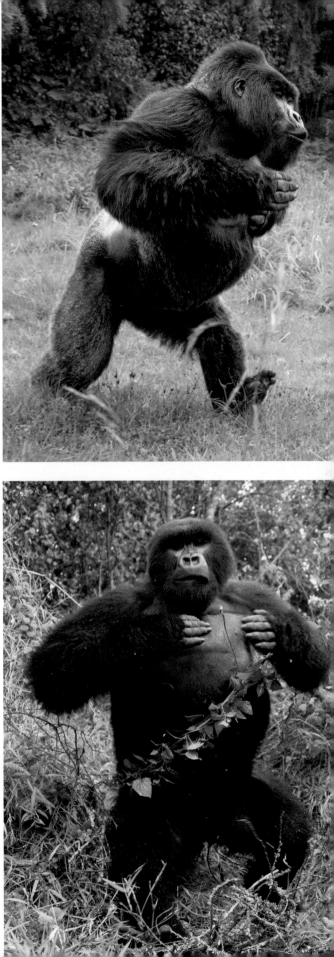

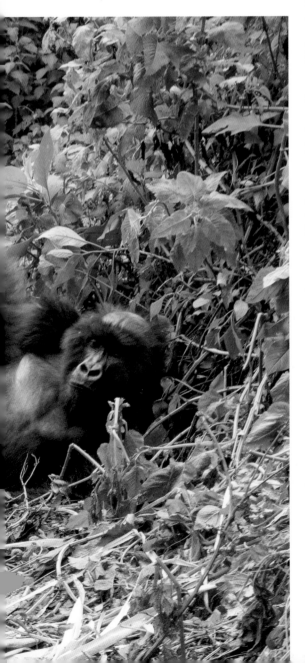

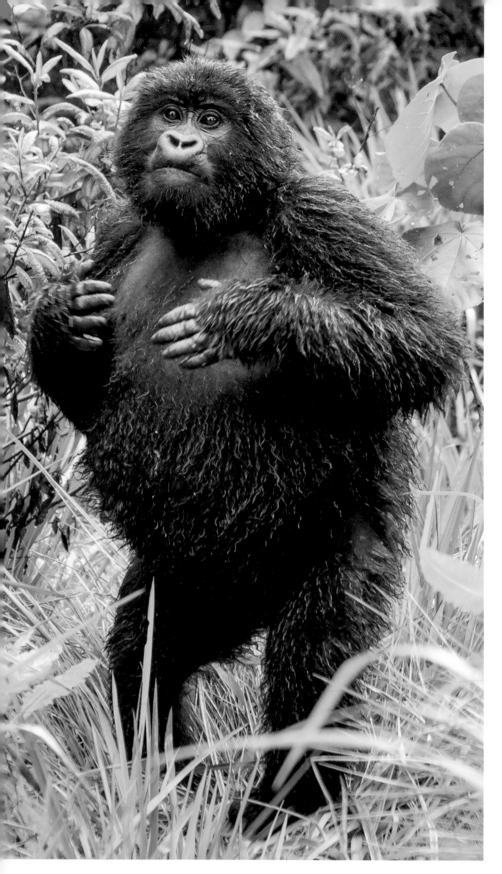

Practice Makes Perfect *(left)*. Juveniles often beat their chests, though of course not for the same reasons as the silverback. In these cases, the behavior may be a sign of exuberance and high spirits, of simply feeling good and strong, and, if gorillas are anything like people, they may be mimicking the silverbacks that lead their group.

Someday, I'll Be King *(following page)*. It is particularly endearing to watch a three- or four-year-old baby stand up and chest-beat. Sometimes, in their enthusiasm, they fall backward into the ferns, provoking some chuckles from the human onlookers.

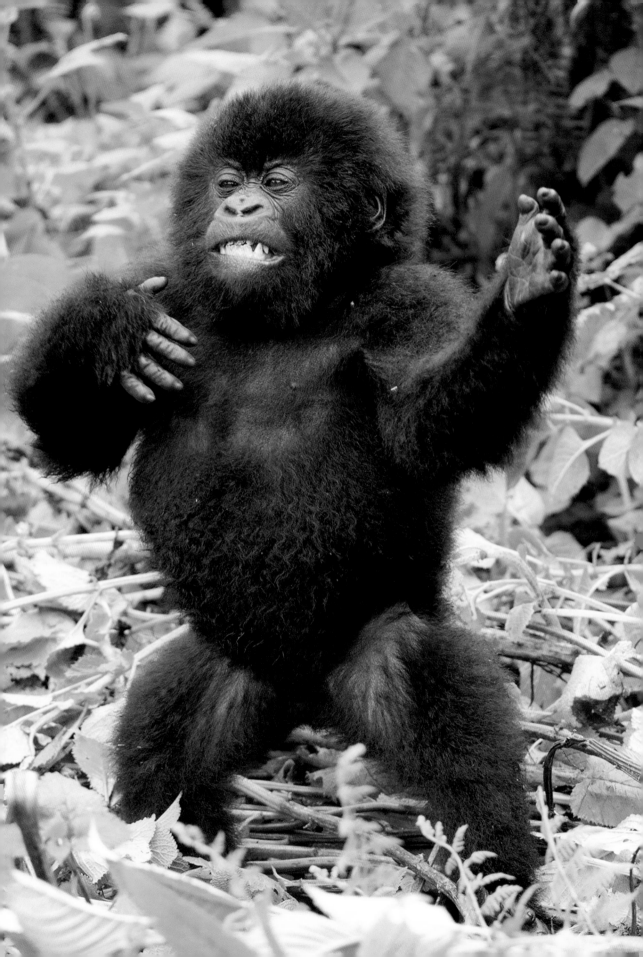

THE WAR

The most exciting day we ever had with the mountain gorillas, and arguably one of the most exciting days I've ever had with any animal, occurred on our 75th gorilla trek. We had been photographing the Sabyinyo group feeding in a eucalyptus grove, and as they were about to return to the forest, another group, Hirwa, appeared. Suddenly, the day got very interesting.

Although Sabyinyo's group had three silverbacks, Hirwa's lone silverback was huge, and he was not intimidated by the other three. The two groups advanced toward each other, the silverbacks in the lead, posturing often by standing

Hirwa's Silverback *(below)*. The lone silverback in Hirwa was huge, and as a displacement activity, he tore at vegetation, showing his might. Note, too, that his upper lip is puffed out, a sign of annoyance.

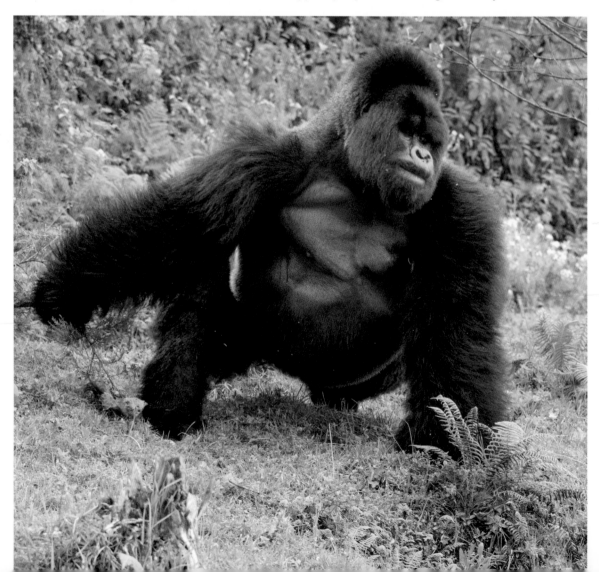

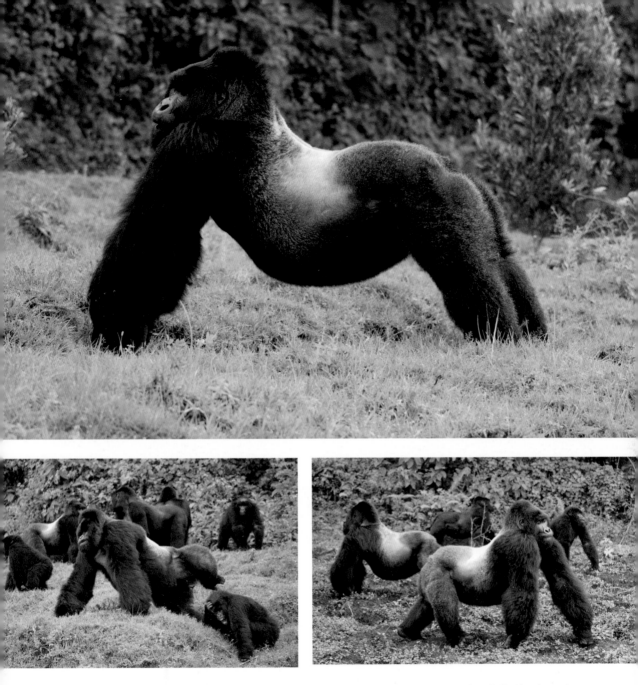

Silverback Display *(top).* Stretched out to his full length and facing sideways, this visual display broadcasts this gorilla's size and vigor, and is meant to intimidate rivals. Hirwa's silverback wasn't impressed.

The Kick *(bottom left).* Often, after a chest-beating display or a charge, a silverback does a strange kick. We've seen it often, and oddly enough, there has frequently been a baby ducking right underneath. This juvenile doesn't look too happy, but we've never seen physical contact in these kicks.

Posturing Soldiers *(bottom right).* All three of Sabyinyo's silverbacks strutted about, much as a human might stand fully upright with his chest puffed out to look as big and intimidating as he can. Posturing like this might deter a more serious confrontation.

sideways and stretching out, fully revealing both their size and their prominent silver saddles. Occasionally, as part of the nearly continuous intimidation display, one of Sabyinyo's silverbacks would race by our group, so close that he was within touching distance. As he pounded by, we could literally feel the earth shake. Mary believes the silverbacks engaged in this behavior to claim us as a part of their group.

Remarkably, there was rarely any physical contact during the entire encounter. On two occasions, Hirwa's silverback and one of Sabyinyo's would swat at each other, a move that resembled a "hgh five," rather than an aggressive blow, though the latter was the intention. At one point, two rival silverbacks came within yards of each other, posturing all the while. Suddenly and without warning, the two came into real contact in a confusing roll downhill that ended seconds later, with neither showing any sign of injury.

One of our most interesting observations was the tongue-wagging display of the silverbacks, who would stick out their tongues and wiggle them back and forth. This reminded me of New Zealand's Maori and their soccer (football) team, who do something similar as their own unique form of intimidation. Researchers we showed the images to had never witnessed that behavior.

A Blackback Joins In *(top)*. Blackbacks, those males approaching maturity but still lacking the distinctive silver saddle, will play a role in the group's defense, posturing about to reinforce the sense of threat.

The Tongue Wag *(bottom)*. This composite photo shows the left-right head swings of the silverbacks during the weird tongue-wagging display. Though this behavior may be rarely seen, we believe it is a common display in these types of intimidation battles.

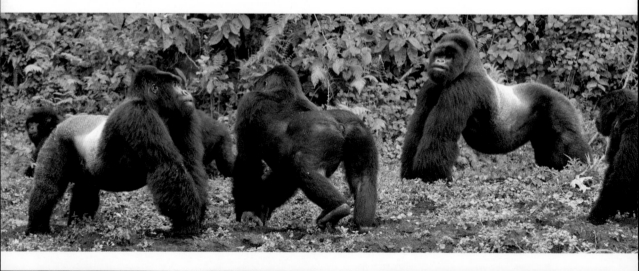

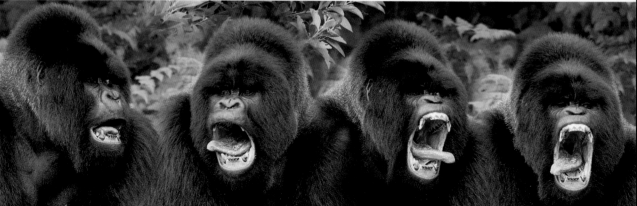

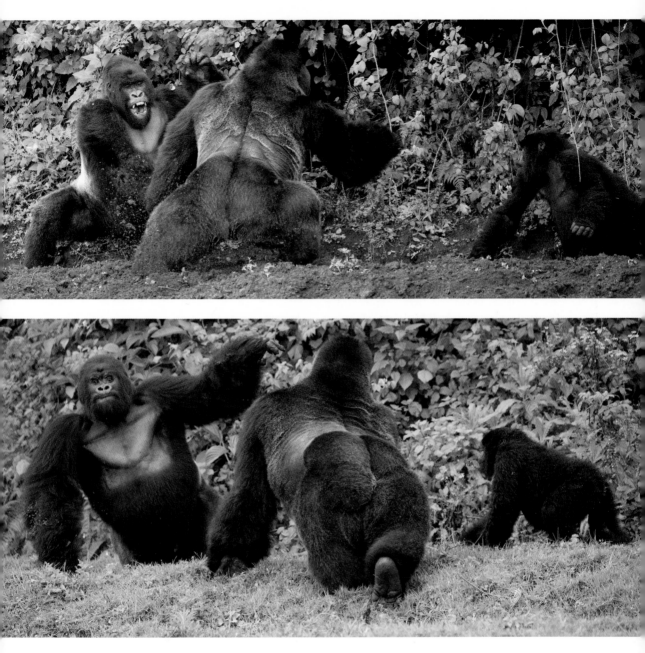

Confrontation *(top)*. The confrontation lasted only seconds, but I can tell you there are few encounters more exciting to see than 800-plus pounds of mountain gorillas charging at one another. In this confrontation, there was no more physical contact than a hand slap.

Giving Way *(bottom)*. Hirwa's silverback charges in, while one of Sabyinyo's silverbacks turns sideways to avoid contact. Actual fights present the risk of debilitating injuries that could prove fatal, even for the victor. Consequently, it makes more sense to win a contest by bluff.

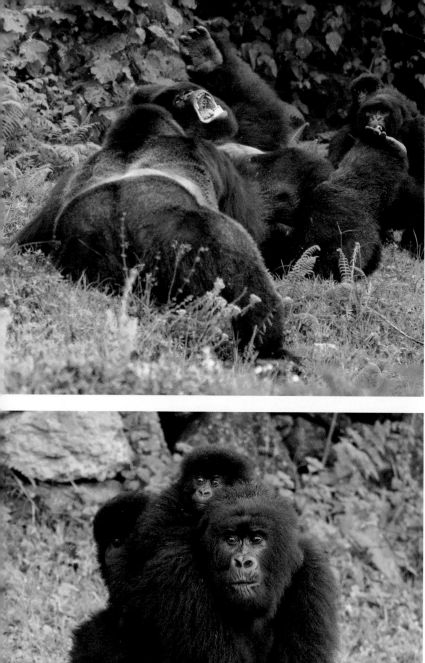

These encounters normally take place deep inside the forest, where the views are limited or absent, and the only clue anything is really happening comes from the screams and chest-pounding of the participants. In 20 or more years of nearly daily treks, our most experienced guide had only seen anything resembling this two or three times, so we felt especially lucky, even more so as it marked our 75th trek!

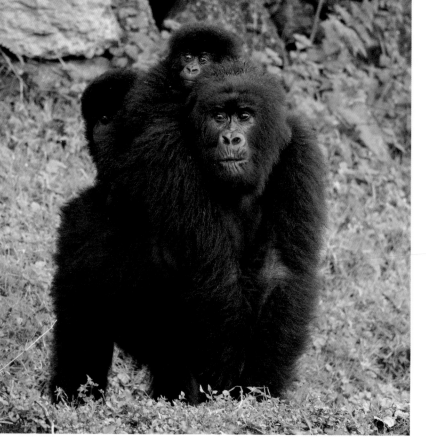

Contact *(top)*. In the entire 40-minute confrontation, there was only one true clash, when Hirwa's silverback and Sabyinyo's boss silverback grappled and rolled down a hill. When they stopped, just seconds later, the two separated, with both appearing to be uninjured from the bout.

A Concerned Onlooker *(bottom)*. One of Hirwa's mothers, the only mountain gorilla at the time with twins, looked on, the concern on her expressive face quite obvious.

THE FUTURE

Mountain gorillas are a true success story, as their population has increased four-fold over 60 years. Rwanda's government has done an exemplary job in mountain gorilla conservation, and one can only hope that future politics or administrations continue in the same fashion.

Tourism comprises one of Rwanda's primary sources of income. Mountain gorilla viewing is responsible for much of this, but many argue that the tourists are loving the gorillas to death, as contact with tourists can transfer diseases and threaten the population. To lessen the chances of this and other tourist-related concerns, Rwanda has increased the daily fee for a visitation, jumping from $750 to $1500 in 2017. When we first visited Rwanda around 15 years ago, the permit fee was $250, but park authorities believe that the new fee for one hour of gorilla viewing will limit the number of

Mountain gorillas are a true success story, as their population has increased four-fold over 60 years.

Eucalyptus Scars *(below).* Eucalyptus trees native to Australia are fast-growing and are planted in groves for charcoal and other uses. Gorillas have discovered, somehow, that the sap of this tree is tasty, and possibly medicinal, and family groups occasionally descend from the forest to enjoy a different snack.

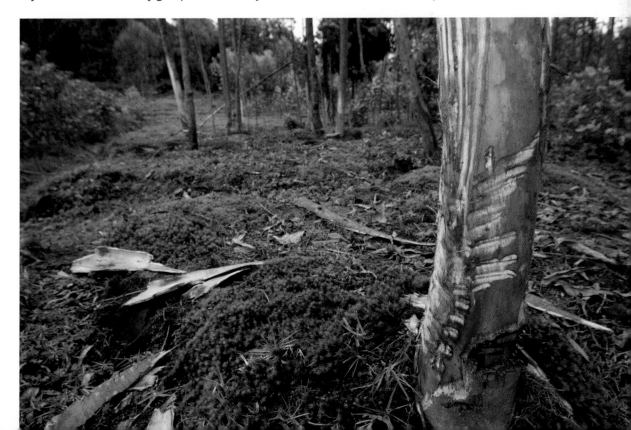

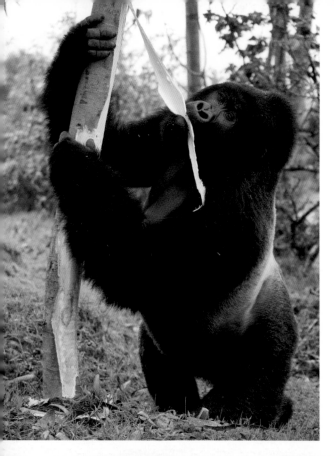

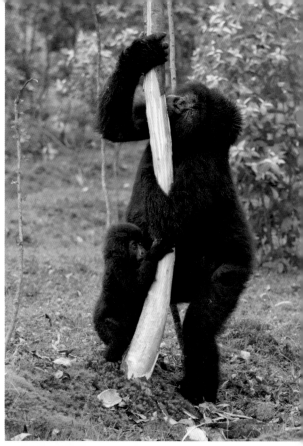

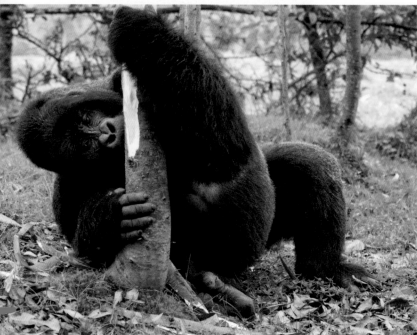

Silverback Stripping a Tree *(top left)*. When a tree completely loses its bark, it dies. Fortunately, Rwanda's conservation program reimburses farmers for any damages or economic losses, preserving the necessary goodwill of the local farmers.

Mother and Baby Feed *(top right)*. While his mom fed, this baby mountain gorilla watched and eventually imitated her, attempting to scrape some tasty fiber himself.

The Beaver *(bottom)*. You might think that the weird debarking and tooth marks on these trees were made by beavers—and when you see a silverback in action, you still might be reminded of a beaver!

tourists, while maintaining the revenue needed not only for Volcanoes National Park, but for other conservation projects throughout the country.

These are valid points, but the cost of a permit has discouraged many, who question whether the total costs, in travel, lodging, and food, can be justified, especially if they can now only afford one visit. Mary and I have led 20 trips to Rwanda, where each visit included five mountain gorilla treks, which ensured that the six photographers who accompanied us would have a good chance on at least one day for great light, great settings, and cooperative gorillas. Those longer visits may no longer be possible for anyone but the well-heeled. Those of more modest means may never have a chance to see wild gorillas, and will not be able to share their experiences and passion with others when they return home.

This troubles me, as most of the tourists we've traveled with couldn't afford to now make a lengthy visit. That said, I fervently hope that Rwanda's present policy has the positive impact that is intended, and the mountain gorillas continue to prosper. Being with this magnificent animal, as Mary and I hope our images convey, is truly one of the all-time greatest wildlife experiences one could ever have, one that will move you to your soul, humbling and enchanting you while in their company.

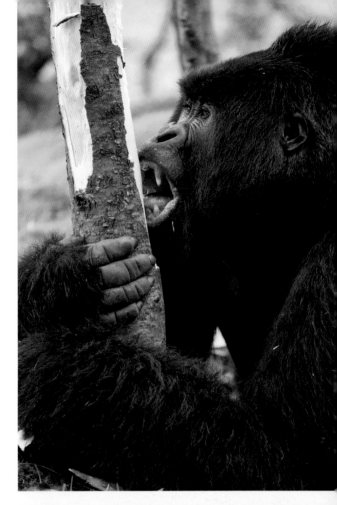

Silverback Uses His Teeth *(top)*. Gorillas usually use their incisors to scrape into the soft tissue of the tree, creating the gouging and etching that scars many trees.

Scraping *(bottom)*. Mountain gorillas are only interested in the soft tissue below the bark, and except for the rare tree that is pulled down and broken, the trees recover, provided bark isn't removed completely in a girdling fashion.

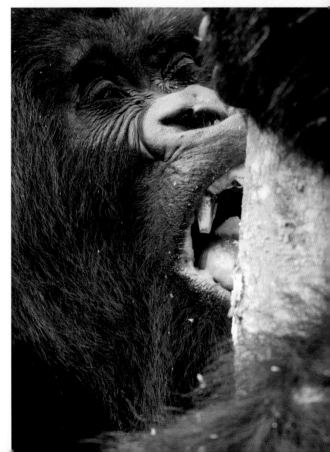

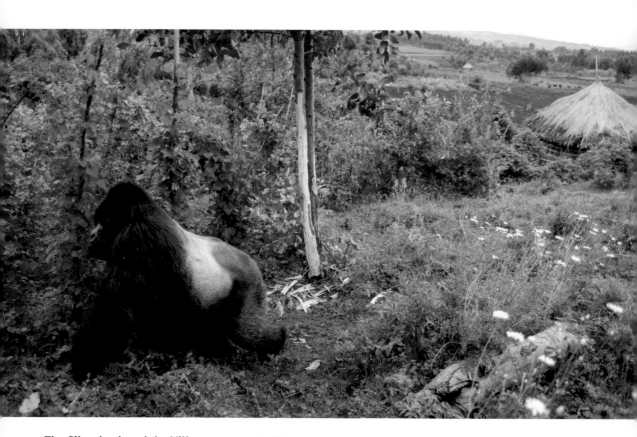

The Silverback and the Village
(above). This was another winning entry in the prestigious BBC Wildlife Photographer of the Year competition, illustrating the potentially troublesome juxtaposition of wildlife and human habitats.

Islands of Sanctuary *(following page, top)*. High on a hilltop on the slopes of a volcano, a silverback pauses while eating his bamboo lunch. Surrounding the volcanic highlands on all sides are farm fields, making the gorillas' home a true island in a sea of humanity.

A Family Surveys Their World *(right)*. I'm troubled by this image. I wonder what this mother thinks, although I'd suspect she doesn't worry or fret over habitat loss, though her world represents only a tiny fraction of the landscape.

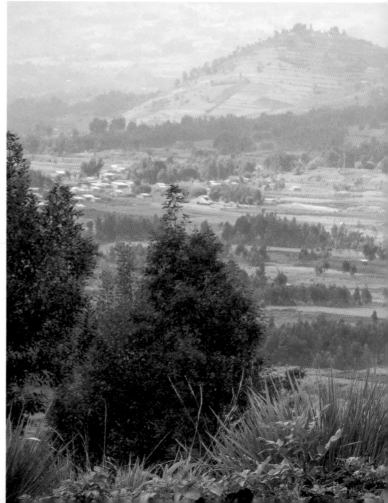

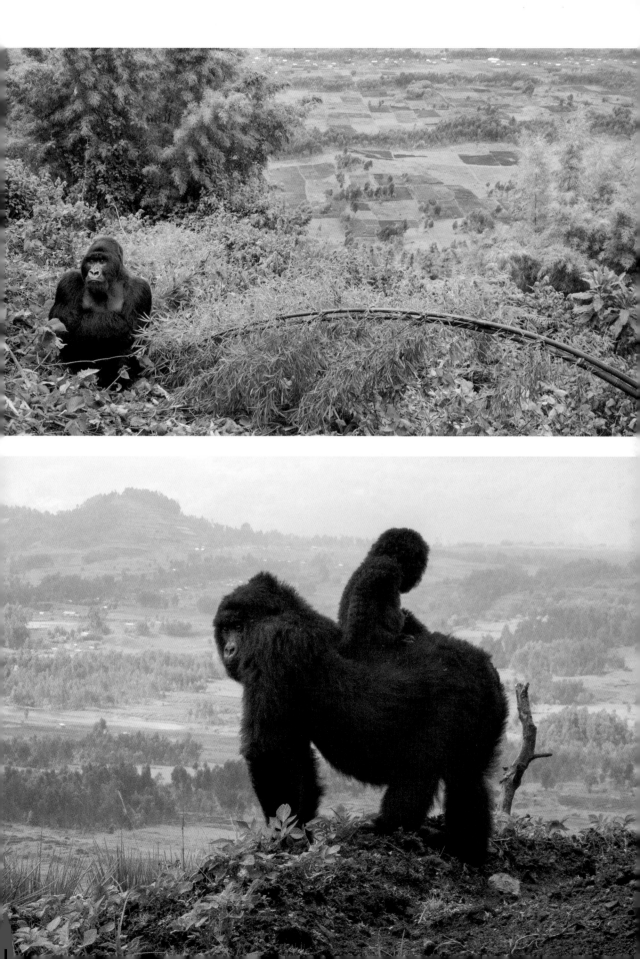

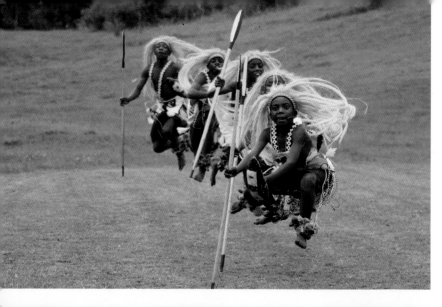

Rwanda Dancers *(top)*. Having visited Rwanda for over 15 years, we've watched children in dance troops grow up to become hotel owners, tourist guides, or part-time professional dancers entertaining tourists at park headquarters and various lodges.

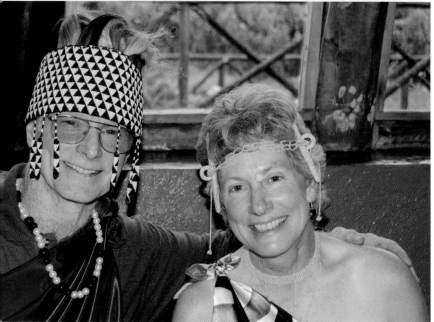

The King and Queen *(center)*. Mary and I have brought over a million dollars' worth of tourist business to Rwanda over the years, which has been much appreciated and a cause for major celebrations at the anniversaries of our 50th, 75th, and 100th treks, when we were ceremoniously crowned king and queen. The title lasted only the day!

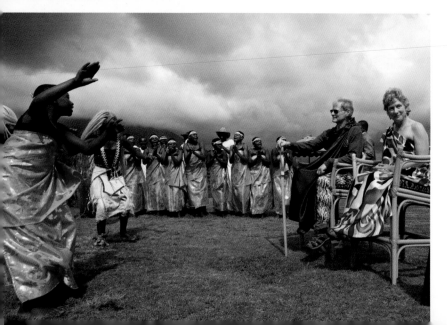

The Ceremony *(bottom)*. We are very proud to have been a small part of Rwanda's mountain gorilla success story, and here, as the "royal" guests, we're being entertained by one of Rwanda's talented dance troops.

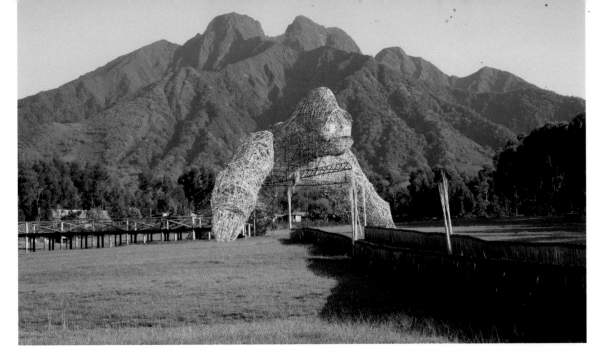

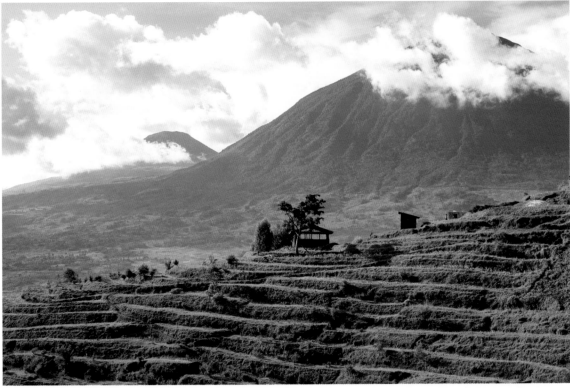

The Kwitza Inza Ceremony *(top).* One of the highest honors one can have in wildlife conservation is to be a "namer" at the Kwitza Inza naming ceremony, where that year's "crop" of babies are given their official names. In 2016, Mary was picked to do so, and in 2017, I had the same honor. An enormous gorilla constructed of bamboo marked the entrance to the ceremony grounds.

Terraced Farm Fields *(bottom).* Seen from afar on a clear day, the vulnerability and isolation of the mountain gorillas' habitat is starkly evident. Farm fields bisect the land right to the park's boundary fence.

Making Charcoal *(top).* The eucalyptus trees are cut and burned for charcoal, the main fuel source for most of rural Rwanda. Lake Kivu, on the border of the DRC and Rwanda, has an enormous methane reserve buried beneath it, and this resource may someday supply much of Rwanda's power needs.

Tourists *(center).* Though tourists are requested to forgo a visit if they have a cold or another illness, one must wonder how many comply. The risk of transmitting a disease or illness is ever present, and is one of the reasons for the decision to increase the fees for the one-hour visit with the gorillas.

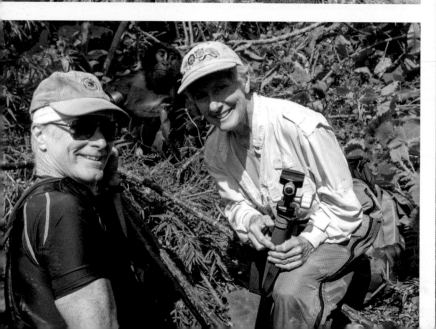

The Ultimate Selfie *(previous page, bottom)*. Mary and I in the final minutes of one of our treks, where tourists sometimes get to pose with a gorilla or gorilla family in the background. It's the ultimate selfie!

Mary and Guard *(right)*. The end of a trek. Mary is being assisted in climbing down from the six-foot fence that marks the park's boundary. We fervently hope that every nature lover will be able to one day share in this experience.

Silverback Retreats into the Forest *(below)*. With a steadily growing population, the mountain gorilla's future is bright for now, and we hope that it always remains so.

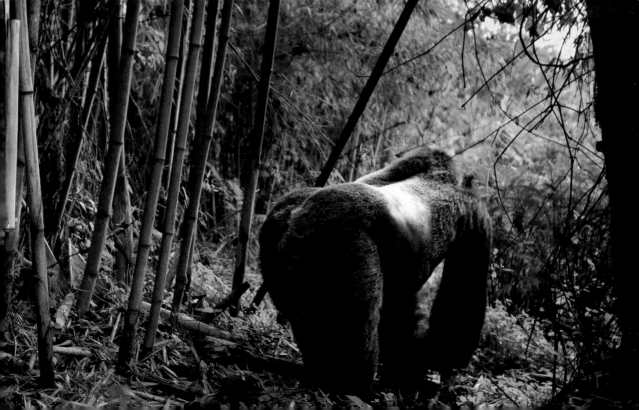

INDEX

AmherstMedia.com

- New books every month
- Books on all photography subjects and specialties
- Learn from leading experts in every field
- Buy with Amazon (amazon.com), Barnes & Noble (barnesandnoble.com), and Indiebound (indiebound.com)
- Follow us on social media at: facebook.com/AmherstMediaInc, twitter.com/AmherstMedia, or www.instagram.com/amherstmediaphotobooks